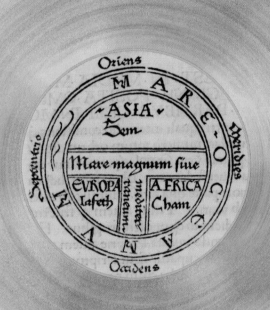

Oriens

MARE·OC

ASIA
Sem

Mare magnum siue

EVROPA
Iafeth

AFRICA
Cham

Occidens

world views: Maps & Art

Preceding page

Isidore of Seville (Spanish, 560– 636),
T-O Map of the World, 1472. Woodcut.
In *Etymologiae*. James Ford Bell Library,
University of Minnesota.

This simple yet powerful map is the first image of
the world printed in Europe. It is a Christian
T-O map. The East appears at the top, North at
the left, Jerusalem at the center. The "ocean
sea" encircles the whole. Waterways (the Nile and
Don rivers and the Mediterranean Sea) separate
three continents (Asia, Europe, and Africa) and
form a cross.

world views: Maps & Art

Robert Silberman

in collaboration with Patricia McDonnell

Essay by Yi-Fu Tuan

11 September 1999 – 2 January 2000

UNIVERSITY OF MINNESOTA

Distributed by the University of Minnesota Press
Minneapolis and London

This book is published in conjunction with the exhibition *World Views: Maps and Art,* organized by the Frederick R. Weisman Art Museum, University of Minnesota, and on view 11 September 1999 – 2 January 2000.

This exhibition and catalogue have been made possible through the generous support of the James Ford Bell Foundation, the Elizabeth Firestone Graham Foundation, and the National Endowment for the Arts. The Institute of Museum and Library Services, a federal agency that fosters innovation, leadership, and a lifetime of learning, supports the Frederick R. Weisman Art Museum at the University of Minnesota. Additional operating support is provided by the General Mills Foundation, the Colleagues of the Weisman Art Museum, and the University of Minnesota.

Reproduction credits:

Saul Steinberg, *View of the World from 9th Avenue,* p. 39. © 1999 Estate of Saul Steinberg/Artists Rights Society (ARS), New York. Photograph by Ellen Page Wilson; Jasper Johns, *Map,* p. 51. © Jasper Johns/Licensed by VAGA, New York. Photograph by Paula Goldman; Jaune Quick-to-See Smith, *Indian Country Today,* p. 50 © Jaune Quick-to-See Smith. Photograph by Brent Wahl; Clay Tablet Map, excavated at Yorghan Tepe, Iraq, p. 18. © The President and Fellows of Harvard College; Richard Long, *A Line of Nights,* p. 42; Raven Maps and Images, *Montana,* p. 15. Photograph by Jerry Mathiason, Minneapolis; Kim Dingle, *United Shapes of America III (Maps of the U.S. Drawn by Las Vegas Teenagers),* p. 40. Photograph by Robert Fogt, Minneapolis; Marshall Island stick chart, p. 33. © The Field Museum, Chicago, #A92511; Lothar Baumgarten, Installation view of *AMERICA Invention,* p. 44. Photograph by Ellen Labenski. © The Solomon R. Guggenheim Foundation, New York; Installation photography of works commissioned for the exhibition *World Views: Maps and Art,* pp. 56–75, by Robert Fogt, Minneapolis; Map projections, p. 14, by Philip M. Voxland; black-and-white photographs p. 71 courtesy North American Treaty Organization; Black-and-white photograph, p. 74 (top center) Courtesy North American Treaty Organization; black-and-white photograph, p. 74 (bottom left) courtesy German Bundeswehr; satellite images not otherwise credited, pp. 70–75 © CNES/SPOT Image Corporation. Software provided by ER Mapper.

Published by Frederick R. Weisman Art Museum University of Minnesota 333 East River Road Minneapolis, Minnesota 55455

International Standard Book Number 0-8166-3686-9

Library of Congress Cataloging-in Publication Data
Silberman, Robert Bruce, 1950–
World views: maps and art: September 11, 1999–January 2, 2000/Robert Silberman in collaboration with Patricia McDonnell; essay by Yi-Fu Tuan.
p. cm.
Includes bibliographical references.
ISBN 0-8166-3686-9
1. Maps in Art–Exhibitions.
I. McDonnell, Patricia, 1956–
II. Tuan, Yi-Fu, 1930–
III. Frederick R. Weisman Art Museum. IV. Title

N8222.m375 S54 1999
704.9'49912—dc21
99–040226

Designer: **Craig Davidson, Civic Design, Minneapolis**
Editor: **Phil Freshman, Minneapolis**
Printer: **Printcraft, Minneapolis**
Distributor: **University of Minnesota Press, Minneapolis**

The Frederick R. Weisman Art Museum is pleased to present *World Views: Maps and Art*, an exhibition that examines a significant subject and offers an opportunity for collaboration among artists, curators, and scholars from several disciplines. It explores the rich relationship between art and maps that has persisted from the first century A.D. to the present moment. The artists who were commissioned to make works of art for the exhibition bring the consideration of that relationship, literally, up to the closing quarter of the twentieth century. This is an exhibition that will offer insights to art-sophisticated audiences and students as well as to visitors who may have less experience with art. In these respects—the examination of significant subjects, interdisciplinary collaboration, and education—*World Views* embodies the museum's most essential aims.

I want to acknowledge, first of all, University of Minnesota professor of art history Rob Silberman, who proposed this project to the Weisman. He served as guest curator, and his careful study and thoughtful conclusions are evident in the exhibition and here in the catalogue. His collaborator, Weisman curator Patricia McDonnell, provided not only ideas and intellectual consultation but also the organizational skills required to make concepts take concrete form in the galleries and this book. Yi-Fu Tuan, emeritus professor of geography at the University of Wisconsin–Madison, wrote an exceptional catalogue essay and provided valued counsel for Silberman and members of

the Weisman staff. Carol Urness, curator at the James Ford Bell Library, University of Minnesota, has been indispensable at every turn. She responded with enthusiasm to the project, devoted many hours to it, and made her keen insights into and knowledge of the history of maps readily available to us.

We thank the following commissioned artists for the challenging installations they created and for the delightful working experience they afforded us: Emilia and Ilya Kabakov; Laura Kurgan; and the KNOWMAD Confederacy, whose members include Rocco Basile, Emil Busse, Mel Chin, Tom Hambleton, Brett Hawkins, Andrew Lunstad, Jane Powers, Chris Parrish-Taylor, and Osla Thomason-Kuster.

We are likewise thankful for the incredible talents of cartographer Mark Lindberg, director of the Cartographic Laboratory, Department of Geography, University of Minnesota. He worked as a technical consultant and also made the complex maps for the Kabakov installation. Philip Voxland, professor of information technology, University of Minnesota, helped make map projections for the catalogue.

Sam and Farzan Navab of the Oriental Rug Company, Minneapolis, were exceptional consultants to the KNOWMAD Confederacy. Charlene Engen of Tierney Brothers, Inc., Minneapolis, provided important technical production advice for Laura Kurgan. The staff of the University of Minnesota's John R. Borchert

Map Library responded to our many queries and deserves our gratitude. We also owe thanks to Maria T. Zuber of the Mars Orbiter Laser Altimeter Science Team and the Massachusetts Institute of Technology and to Steve Hademeyer and Lou Giordano of the *New York Times* Map Department.

Thanks go as well to editor Phil Freshman and catalogue designer Craig Davidson for their fine work.

Weisman staff members all performed in their characteristically professional, efficient, and creative way. A few special notes of recognition are in order. Besides Patricia McDonnell, I want to mention Kathleen Motes Bennewitz and Susan Weir, who poured much energy into the project, negotiating requests for catalogue illustration material and assisting in countless ways with the artists' commissions. Mark Kramer designed the exhibition and aided the commissioned artists with their specific requirements. Warm thanks also go to Tim Herstein, who did a great job with the special mounts for the antique maps and atlases; to Susan Rotilie for helping obtain satellite imagery for Laura Kurgan's installation; to Weisman registrar Karen Duncan for her able administration of shipping; and to Kathleen fluegel, the museum's development director, whose creative thinking led to some wonderful support for the exhibition.

On behalf of the Weisman staff, I wish to express gratitude to the following individuals for helping arrange the loaned works that greatly enhance the exhibition: Carol Urness, James Ford Bell Library, University of Minnesota, and her staff, including Brian Hanson and Brian Oftelie; Karen Nelson Hoyle, Children's Literature Research Collections, University of Minnesota, and her staff, including Kim Kahlhamer; Tim Johnson, Special Collections and Rare Books, University of Minnesota; Evan Maurer, Joe D. Horse Capture, Brian Kraft, and Cathy Ricciardelli, Minneapolis Institute of Arts; Nina Archabal, Patrick Coleman, Karen Lovaas, and Tanya Fischer, Minnesota Historical Society; Kathy Halbreich and Elizabeth Peck, Walker Art Center; Susan Lubowsky Talbott and Rose Wood, Des Moines Art Center; Donald B. Marron, Matthew Armstrong, and Stephanie Hodor, PaineWebber Group, Inc.; David Lieber and Susan Brundage, Sperone Westwater Gallery; Jon Hendricks, Gilbert and Lila Silverman Fluxus Collection Foundation; Heidi Lange, DC Moore Gallery; Bernice Steinbaum and Joanne Isaac, Steinbaum Krauss Gallery; Caroline Nathusius, John Weber Gallery; Isabel Goldsmith; Mike and Penny Winton; Kim Dingle; Yoko Ono; and Miguel Angel Ríos.

Finally, without grants and in-kind support from the following, this exhibition and book would not have been possible: the James Ford Bell Foundation; the Elizabeth Firestone Graham Foundation; the Archie D. and Bertha H. Walker Foundation; the National Endowment for the Arts; and Tierney Brothers.

Director's Foreword

Lyndel King

07

It has been a pleasure to work once more with the Weisman Art Museum. My first and greatest thanks must go to Patricia McDonnell, curator at the Weisman and the coordinating curator for *World Views: Maps and Art*, because without her this exhibition and catalogue simply would not have happened. I can thank my lucky stars for again being the beneficiary of Patricia's extraordinary professionalism, hard work, shrewdness, tact, and good humor.

So many people at the Weisman have contributed in so many ways that it is almost unfair to single out individuals. But I would like to thank Lyndel King, the museum's director, for her personal support for the project and as the representative of the entire staff. I must express special gratitude to Kathleen Motes Bennewitz and Susan Weir for the terrific job they did in fighting the good map-and-art fight on 1,001 fronts and to Mark Kramer and Tim Herstein, whose work on the planning and installation was invaluable. In addition, Kathleen Fluegel deserves thanks for her fund-raising efforts, as does Colleen Sheehy for once again developing excellent educational programs.

As a total novice in map matters, it was my good fortune to be able to rely upon the expertise of Professor Carol Urness, curator of the University of Minnesota's James Ford Bell Library; she has been a joy to work with. From a greater distance, Yi-Fu Tuan and David Woodward of the University of Wisconsin–Madison proved that the phrase "a gentleman and a scholar" continues to have meaning. David sent news of other map-and-art exhibitions, and he responded unfailingly to a barrage of inquiries. Yi-Fu made my day, week, month, and year by writing an essay for this book that is a wonder. My thanks go to all three for their enthusiasm and aid.

Curator's Acknowledgments

Robert Silberman

My thanks also go to Lynne Cooke of the Dia Center for the Arts, New York, and Rob Storr of the Museum of Modern Art, New York, outstanding curators who have been models of collegiality, providing essential information and advice. Lucy Fellowes, who co-curated the 1992 exhibition *The Power of Maps* at the Smithsonian Institution's Cooper-Hewitt National Museum of Design in New York, discussed that important show with me and told me about Laura Kurgan.

To Laura, to Mel Chin and the KNOWMAD Confederacy, and to Ilya and Emilia Kabakov go my affectionate and respectful thanks. It has been an honor to work with you on this project.

Two people deserve special medals for grace under pressure: Phil Freshman, for his sympathetic and skillful editing of my essay; and Craig Davidson, who contributed another masterful catalogue design.

Of the many others who have helped me in various ways during the course of this project, I must express gratitude to Svetlana Alpers, Rick Asher, Lothar Baumgarten, Marie-Ange Brayer, Michael Brenson, Deborah Butterfield, Patrick Coleman, Tom Conley, Zelimir Koscevic, and Jon Walstrom.

Anedith Nash was with me on the roller coaster from start to finish; I cannot begin to express how much her companionship has meant.

I conducted preliminary research for this exhibition on a sabbatical leave that was made easier by supplementary funds from a Bush Foundation Sabbatical Grant. I am happy to thank the University of Minnesota and the Bush Foundation for their support, which I hope has been rewarded.

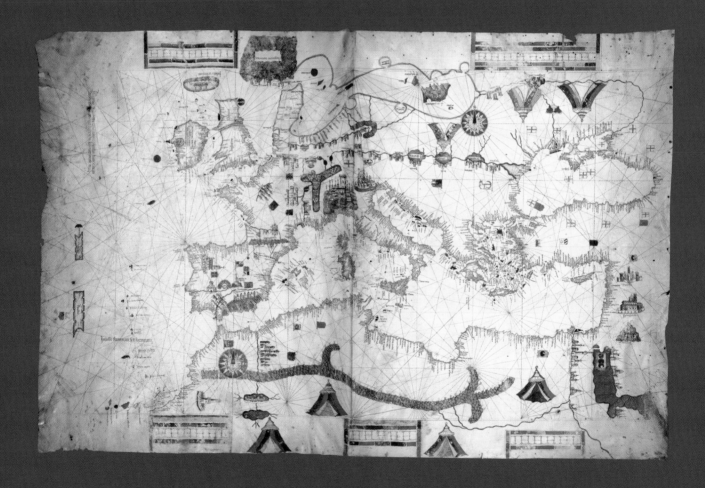

Figure 1. Albino de Canepa (Genoese, active 1480–90), Portolan Chart, 1489. Hand drawn and hand painted on vellum. James Ford Bell Library, University of Minnesota.

This Portolan, or navigational, chart is hand drawn and hand painted on two joined sheets of vellum. Because mariners used this map, coastlines, reefs, and shoals take precedence. The pattern of lines on the chart helped mariners plot their course. Land areas, of little importance to sea travelers, are embellished with fanciful ornament and are mainly decorative.

Maps and Art: Identity and Utopia

Yi-Fu Tuan

How to get from here to there? Consult a map! So the map is a tool—a device that helps one to achieve a goal. The first maps were probably drawn on sand, as one man told another how to reach the water hole or marketplace. Even this most basic sort of map implies a fairly complex society in which not all members know where the key resources are, or a society in which long-distance travel by water or land is a fact of life. Such travel would require even natives to learn routes and navigational techniques in a more or less formal manner.[1]

Maps drawn on sand, merely to answer a practical question, typically have little or no artistic value. However, as soon as they are drawn on more durable material—clay, wood, papyrus, or paper—the artistic urge finds expression. It is as though human beings are incapable of inscribing lines, angles, squares, and circles without becoming engulfed in the aesthetics of pattern and design. This urge is all the more powerful when color and the pictorial representation of topographic and man-made features are added. Initially, they may have been added to increase the amount of information and enhance the ease of reading. But once introduced, the aesthetic impulse can acquire a life of its own and develop at the expense of accuracy and even readability.

SCIENCE AND ART

Societies that have a mapping tradition appear to experience the twin pull of practicality and imagination—science and art. In some, art triumphs so that maps have little or no practical use and would not even be called "maps" under a strict definition. One such example might be the pilgrim-route maps and sand mandalas of Tibet, which reflected mythology more than they did geography.

In other societies, outstandingly that of ancient China, a greater balance was reached. Historically, Chinese maps strove for accuracy because they served pressing secular needs, such as gaining military success, controlling flood-water, and establishing property boundaries. A remarkable example of early achievement were the silk maps of Hunan province, found in a tomb dating back to about 150 B.C. On them appeared the locations of army installations and headquarters; color was used to distinguish different kinds of geographical features and to provide some evidence of scale. Given this early start in scientific mapping, how is it that China eventually fell so far behind the West in that field of endeavor? One answer might be the intimate bond—the *too* intimate bond—between maps and landscape art. Chinese landscape painting flourished from the eleventh century onward. Many paintings portrayed idealized scenes of "mountains and rivers," but some were bird's-eye views of actual towns and the surrounding countryside. How should we classify these bird's-eye views—as landscape paintings or as maps? It is plausible to say that they were both, that a fusion of genres had occurred such that works motivated primarily by aesthetics could also be used to help one find one's

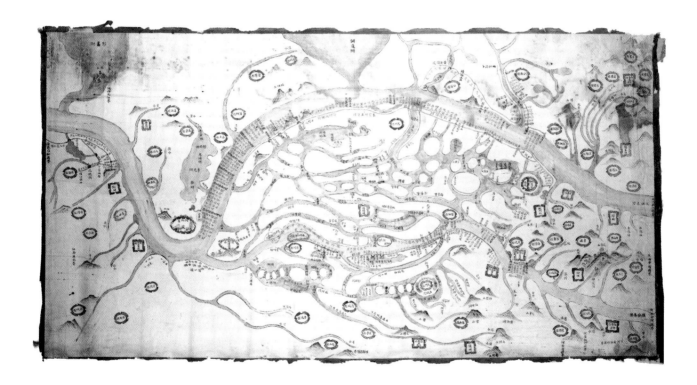

Figure 2. This 19th-century Chinese map depicts the sinuous, dragonlike Yangtze and Han rivers. Geography and Map Division, Library of Congress.

way around town. But for this reason—though obviously not for this reason alone—the empirical-scientific movement in Chinese cartography failed to soar. Even nineteenth-century Chinese maps, with their sinuous, dragonlike rivers and hills in profile, remind today's viewers of landscape art (fig. 2). Another possible factor is the importance of words and calligraphy in Chinese civilization. Unlike Western practice, words—many of them!—accompanied both Chinese landscape paintings and Chinese maps. These words or characters were themselves a genre of art. They did not detract from, indeed they seemed to have stimulated, the development of landscape painting. On the other hand, the lengthy texts that went with the maps provided so much information that they seemed to have obviated the need to strive for precision and ampleness of data by cartographic techniques alone.[2]

WHY NOT SCIENCE-*AND*-ART?

Cartography is a supreme achievement of Western culture inasmuch as it (unlike cartography in other cultures) made consistent progress in the direction of science without sacrificing aesthetic sensibility. Maps that have become more accurate and useful can simultaneously provide a tonic for the imagination. The development might take separate paths. In the Middle Ages, for instance, the science—the practicality—of Portolan charts (fig. 1, p. 10) evolved separately from and was balanced by the art—the aesthetic and religious power—of the cosmogonic, or T-O maps (p. 1); the one answered to the need of commerce and navigation, the other to the desire for a "map" of human destiny.[3] Cartography, however, did not begin taking off as science-*and*-art, a merging of the two paths in the same work, until about 1500. No doubt the growing awareness that real geographical knowledge could be had, almost matching in strangeness the previous ungrounded products of fantasy, provided a stimulus.

The principal scientific challenge to cartography was and still is how to present a three-dimensional body, the Earth, on a flat surface. Only the Greeks and their intellectual descendants (Arab and European) sought to confront this challenge. Other peoples were barely aware that there was even a problem. The best response to the challenge lies in mathematical projections. As a technique for making maps and charts that could help long-distance navigators, geometric projections were employed late. An outstanding early success was a cylindrical grid devised by the Flemish cartographer Gerhard Kremer (1512–1594). In this grid (widely known as the Mercator map projection; fig. 3, p. 14), great circle routes appear as straight lines, a result that is useful to navigators. This is achieved by making the parallels of latitude the same length as the Equator rather than having them diminish steadily to a point at the North Pole, and by introducing a corresponding exaggeration in the lengths of the meridians of longitude at higher and higher latitudes. Modern books on geography often criticize the Mercator map projection for these exaggerations because they have the unintended effect (unintended by Kremer) of making middle-to-high latitude European and North American countries (imperial powers, all) appear much larger—hence more important—than they are. But that, of course, is an anachronism: whatever the political designs and passions of our day, Kremer's scientific achievement must be allowed to stand.

Most people are willing to grant the West's scientific prowess. But what about art? There, too, it seems to me indisputable that, in the last five centuries, the cartographic creations of the West have cumulatively shown an aesthetic range and power unmatched in any other part of the world. We need some reminders of this fact. Consider again the map projection. It is not usually considered art. Yet who can deny the beauty of the sinuous curves of an Interrupted Sinusoidal projection? The elegance of its flowing lines depends on the magical economy of mathematics. True, not all map projections are aesthetic: the rectangular net of a Mercator is rather dull. But then, in its reincarnation as Transverse Mercator—all curves except the central line—it is a delight to the eye and, at the same time, is accurate in portraying countries that have a small extent in longitude and a large extent in latitude (fig 3, p. 14).

Cartography is Art. Confronted by the capitalized letters, we are likely to narrow our focus to such widely recognized masterpieces as the Hereford *Mappa Mundi* of the late thirteenth century (p. 33) or Sebastian Münster's world map of 1532, treasures that would have a place in any great art museum. Their aesthetic power lies in a combination of design and symbolic resonance. The Hereford map can boast, in addition, exceptional color vibrancy, and the Münster map exhibits an imagination expansive enough to add an assortment of mythical beasts and monsters beyond the edges of the known world. But the same kind, if not always the

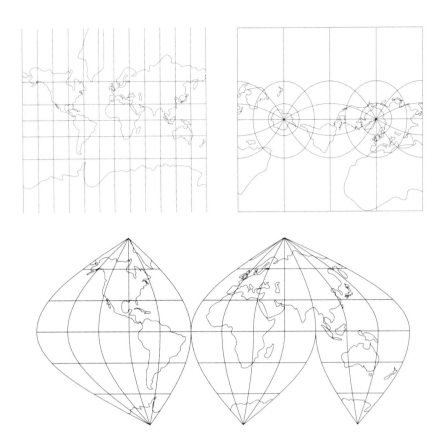

same degree, of excellence could be found in the maps and cosmogonic diagrams of non-Western civilizations, such as those inspired by Hinduism, Buddhism, or the Chinese worldview.

The unique achievement of the West—accuracy combined with beauty—took time to develop. In our century, such conjoint excellence came almost to be taken for granted. Consider modern topographic maps. Made originally for military and other practical ends, they soon acquired aesthetic qualities of immediate appeal. Historical accident may have played a role. In the United States, Clarence King (1842–1901), the first director of the Geological Survey (USGS), was noted not only as a scientist but also as a connoisseur of art.[4] Maps in Europe have of course had a longer history of development, and so it is easier to trace there how precision and beauty could grow in tandem. Take the challenge of depicting relief. Relief depiction, as I have mentioned, did not change much in China. In Europe it changed all the way from profile (artistic but imprecise) to hachures (ugly and only marginally more accurate) to contours (accurate but not very aesthetic) to the wonders of shaded relief— the showpiece of topographic art. Shaded relief achieves a three-dimensional effect by simulating the appearance of sunlight and shadow on the terrain (fig. 4). Such a map is strikingly pictorial; and like all good pictures, its appeal is to far more than the eye alone. Seeing a shaded relief map, I can almost feel the warmth of the sun

and the chill of slopes in deep shade, the smoothness of a hump and the jaggedness of a ridge. And yet it is also accurate. With its help a hiker can find his or her way from lakeshore to mountain peak, knowing just how much of a climb it would be to get up there.

PORTRAIT OF PLACE: A QUESTION OF IDENTITY

A common understanding of the map is that it is the portrait of a place. What is the relationship—what are the similarities and differences—between portraits of place and portraits of people? Let us start with people. In antiquity, only rulers and potentates at the very top of the hierarchy were recognized as individuals. Nevertheless, their images tended to be more iconic than representational. When the elite (not just "semi-divine" rulers) sought to preserve themselves in art, human personality became more evident. This trend continued as, from 1600 onward, ordinary people—members of the rising bourgeoisie—also sat for portraits. Members of the landed gentry, however, wanted to set themselves apart from the newly prosperous. In their portraits (individual and group), the background might show framed landscapes and, sometimes, a county map on the wall. Both provided pleasing decoration, but they were more than that: they were also strong indicators of social status. The gentry might value their individuality, but they valued their heritage and place in society even more.[5]

Some of the world's earliest maps were those

Opposite

Figure 3. Top, left to right: Mercator projection,
Transverse Mercator projection.
Bottom: Interrupted Sinusoidal projection.

Figure 4. Montana ©1991 Raven Maps
& Images. (For more information, call 800-237-
0798, or www.ravenmaps.com.)

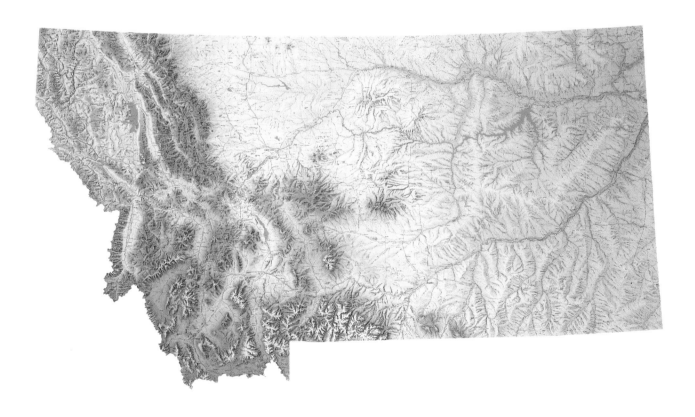

Figure 5. Martin Waldseemüller (German, 1470–1521?), Map of the World on Twelve Gores for a Globe, 1507. Woodcut. Published to accompany Waldseemüller's *Cosmographiae Introductio* (Introduction to cosmography). James Ford Bell Library, University of Minnesota.

This is one of only two remaining copies of Waldseemüller's 1507 map, which was intended to be trimmed and wrapped around a sphere so as to represent the Earth as a globe more accurately. It is the first known map to include the name *America*.

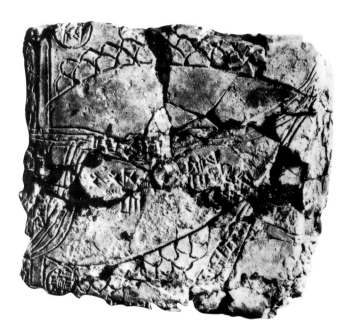

Figure 6. Clay Tablet Map, about 2200 B.C. Excavated at Yorghan Tepe, Iraq. Semitic Museum, Harvard University.

of the city, for example, the Akkadian map from Yorghan Tepe that dates back to about 2200 B.C. (fig. 6) and others (clay tablets in the British Museum) that are of a somewhat later period. What purposes did they serve? We can only guess. The selectivity of the features shown—temple, monumental wall, garden, canal—suggests that the maps and plans were more emblems of power than practical instruments for daily use.**6** Even in historical times, city maps depicted splendid architecture rather than ordinary houses, shops, and streets; they were more communal icons than copies of reality. Such maps used "the best part" of a city to stand for the whole. Which is fair enough, for in human portraiture, too, the figure in fine dress and dignified pose was conventionally taken to be the true, if not the whole, person.

Images of the city changed over time. From the late Middle Ages to 1500, they were little more than abstract symbols.**7** Because they simply stood for the "city," the same symbol—the same profile showing wall and buildings—might be used to represent different places.**8** In the course of the sixteenth and seventeenth centuries, city depiction shifted, successively, from profile to panorama, from panorama to bird's-eye view, and from bird's-eye view to the "view from everywhere." It is the latter view that gives us the familiar modern map. City profiles could show only a few prominent buildings. As the viewpoint moved up and became panoramic, more ordinary structures were revealed and could be depicted.

More and more, houses, streets, market squares, and gardens, rather than churches and palaces, were shown to dominate urban space.

What do these changes imply? For one, increasingly, people took pride in being citizens of a particular city, with its own history and geography. For another, not only great architecture mattered in the calculus of prestige; so did the sheer number of buildings and streets—features that only the map could show. The aesthetic impulse, far from diminishing as the viewpoint shifted higher and higher, seemed to grow stronger with each elevation and broadening of vision. The city in profile was too easy to draw to provide much challenge. The panorama called for a far greater degree of artistic skill. The bird's-eye view required, in the craftsman-artist, a combination of scientific and artistic talent. This combined talent was also required in the vertical view that produced the city map, for up through the seventeenth century, buildings in an urban map might still be shown three-dimensionally, in perspective. Such maps contained sufficient detail and were accurate enough to be of some practical use. But so long as their principal purpose was to serve as a communal portrait or emblem, they had to continue to charm the eye.**9**

If one can be proud of membership in a city, distilling one's sense of identity from it, one can also be proud of membership in a nation-state. In Europe, the "free" city—one with certain political prerogatives—

preceded the nation-state. This means that the deposit of sentiment for the city is thicker, more resonant. But that loyalty is also more easily come by because the city is a tangible place—a world that one can (or could, in old times) encompass in a day's walk and experience directly. The nation-state, being much larger, cannot be so encompassed. Loyalty to it is therefore more dependent on a unifying symbol—crown and flag in earlier times, and, increasingly, the map or atlas. The map or atlas is the largest "family" portrait, a source of pride and identity.[10] An outstanding example in recent years is the three-volume *Historical Atlas of Canada*. Bilingual, bicultural Canada desperately needs unifying symbols. The Maple Leaf flag and the national anthem, created in anticipation of the Confederation Centenary (1967), are not enough. Canadians also require something weightier and more detailed, something that fuses history with geography in the body of a beautifully produced atlas, to give them a collective sense of self.[11]

THE BEAUTIFUL, YES. BUT WHAT ABOUT THE UGLY?

I have drawn attention to two basic types of portrait—that of people and that of place. The last type can be further subdivided into landscape paintings and maps. Portraits of both people and of place promote a heightened sense of self. Yet important differences also exist, above all, that between portraits of people and landscape paintings, on the one hand, and of maps on the other. Although portraits of people are often designed to flatter, the best do not. This is especially true of self-portraits, an outstanding example being Rembrandt's ruthless explorations of himself. All the blemishes of face and figure are shown—and shown, moreover, without a distracting background. The same may be said of landscape painting. Whereas the French artist Claude Lorrain (1600–1682) idealized his landscapes, the Englishman John Constable (1776–1837), working a century later, did not. His portraits of his homeland show her in her natural poses. Looking at them, one expects to see "blemishes"—fences that have collapsed, willow stumps that have rotted.[12]

Now, maps are different. Inherently, they tend to idealize; and this despite their accuracy, despite their ability to show the correct distance between church and market square. Early profiles and panoramas of the city depict, I have noted, only prominent public buildings. Later and modern maps show common buildings as well. However, they make no effort to go a step further and show collapsed fences, potholed streets, and slums. What is true of the city map is also true of maps of the countryside, or of a whole region. All of them, by excluding life's seamier side, can seem utopian. Consider USGS topographic sheets. Looking through them, one might well conclude that all is well with America. What can be amiss when forests are green, rivers and lakes are blue, and settlements are either an eye-catching yellow or a healthy pink, depending on the scale? Conveying rot and degradation cartographically is difficult, perhaps impossible, because maps use conventional signs, which exhibit pattern; and pattern is by its nature aesthetic, whether it represents tulips or sewage pits.[13]

Maps—good maps—embody two kinds of seductive tension. Already noted is that between science and art, between trying to discipline the imagination in the name of accuracy and giving it the widest scope in the name of creativity. Whenever a successful union is found, the result is admirable—a topographic sheet (for instance) that is indispensable to the backpack yet beautiful enough to hang on the wall. The second tension, equally fundamental to the nature of the map, is that of trying to represent, or perhaps merely suggest, both route and goal, both movement and static perfection.

ROUTE AND DESTINATION: UTOPIA

Oscar Wilde famously said, "A Map of the World that does not include Utopia is not worth even glancing at."[14] Wilde liked to shock, to indulge in hyperbole. His hyperboles, however, serve a purpose. They force the reader to wonder whether what Wilde claims has general applicability. Can it be that the root reason why we value maps is that they all contain utopia? A surprising answer is yes, although that "yes" depends on how much weight we give to the word *utopia*. Consider the road maps that gas stations used to provide for free. We spend time with them because they can tell us how to reach Yellowstone or San Francisco, places that we *want* to reach that are therefore, by definition, desirable and good, "utopian" if one exaggerates a little. And isn't even the water hole or Wal-Mart a fleeting utopia—a good place that beckons? Moreover, we may look over a map not for the purpose of going to a place that already exists but with the thought of building a dream house. As our eyes roam over the contoured relief, we envisage a path winding up a slope to a spot that commands the perfect view.

For some people, outstandingly the Australian

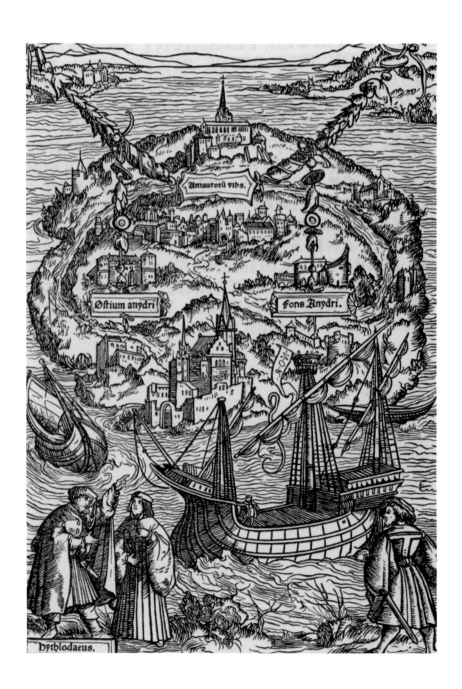

aborigines, the path itself is the good place. Journey's end is not necessarily better, more desirable, than the journey. The aborigines' map is thus made up of paths rather than points—paths they have memorialized and created with chanted stories, or "songlines," as the late writer Bruce Chatwin poetically called them.[15] To most people in the world, however, the paths on a map (mental and actual) are the means to a destination. "Travel" is "travail," and what really matters is the good place at the end. What is the good place like? What makes it a lure? The answer is, much depends on the culture: to hunter-gatherers, the lure may be a rich hunting ground; to modern consumers, the Mall of America. Are there good places—archetypal utopias—that transcend culture? I believe there are. Understandably, the characteristics they share can be stated only in rather general terms.

Both the most widely shared and the most abstract feature of the good place is its location at the center of the cosmos. One has finally arrived when one has reached the *axis mundi*. In some societies, prominently Pueblo Indian, the search for the center is incorporated into foundation myth, which says, in essence, "Our ancestors emerged from the ground in primordial time and traveled, pausing here and there, until they arrived at their final destination."[16] In other societies, the Chinese, for example, the search—the journey—is curtailed or dropped altogether: cosmography trumps cosmogony. Time is cyclical, the eternal alternation of yin and yang, at the center of which is Man or Emperor, humanity at its peak that shades into humbler forms as one moves away from the center.[17] Somewhere between these two extremes lies the European worldview during the late Middle Ages. At the center of the T-O map, stretched over a coordinate of cardinal points, is Jerusalem. Cyclical time is implied by the circular shape and the cardinal points, and yet the Christian understanding of time is singularly historical, anchored by Creation at one end and by the Last Judgment at the other. Christian life itself is typically seen as an arduous journey. And so, contrary to common understanding, T-O maps incorporate stories or linear time (p. 1).[18]

CITY VS. EDEN

What does one find at the *axis mundi*? Answer: in some cultures a Tree, in others a Sacred Mound or some other natural feature. In the more materially sophisticated cultures, one finds the City, which, far from being an imaginary place of the mind, is architecture—a three-dimensional world that one can enter and live in. Many ancient cities were built to reflect a cosmic ideal, places on Earth that exhibited some of the regularity and order of heaven. Beijing, the capital of the People's Republic of China, is a prime modern example. Until the 1960s, when demolition of the monumental enceinte and its gates proceeded apace, Beijing retained the character of a cosmic diagram. Europeans had Jerusalem, a real place, as the primary goal for pilgrimage: the Crusaders fought their way to it. But Europeans also had a more mystical place— the New Jerusalem—to aim for. As described in the book of Revelation, the New Jerusalem is geometric and mineral, a celestial abode as unlike the modest settlements on Earth as possible. It is, however, only a promise—a place that, for the time being, can exist only in the imagination. Yet that is not entirely true. For, from the Middle Ages forward, the faithful in Europe could experience the New Jerusalem, paradise, or heaven (or whatever exalted term one chooses for it) in the solid reality of the great cathedrals. When men and women entered a towering edifice that was suffused in colored light, filled with solemn or soaring music, they could well believe that they were being offered a taste of paradise.

Here, then, is the rub. A taste of paradise or heaven may be all that human beings can hope for. When more is demanded and strenuously put into place, the result can be disastrous. What challenges human beings most is not architecture, for magnificent shells have been built since antiquity, but rather the making of a society that not only lives harmoniously but also is able to rise to a level of moral/intellectual excellence that matches its architecture. Needless to say, societies (past and present) fall far short of this ideal. What to do? One solution is escape. Sophisticated people living in cities, disillusioned with "the center," have their eyes on the "periphery," where they discern a sort of natural Eden, or a small community (utopia) where at least harmony can prevail and the worst forms of social injustice are avoided.

And so the Chinese have conjured images of Eden, Taoist paradise, located at a great distance from the capital. Europeans, too. Even in the best of times, their cities and states could seem chaotic and corrupt, or just too densely populated, to be manageable. When the existence of a New World "out there" was widely bruited, cartographers, like other people, dreamed of idyllic places. These were usually conceived as fertile islands—"island" being an analogue of the garden, an enclosed space of calm

Figure 8. Johannes Ruysch (Dutch or German, died 1533), *Universalior Cogniti Orbis Tabula ex Recentibus Confecta Observationibus* (A more universal map of the known world, prepared from recent observations), 1508. Copperplate engraving, hand colored. In Claudius Ptolemy, *Geographia*. James Ford Bell Library, University of Minnesota.

Mapmakers often updated Ptolemy's atlas *Geographia* by adding maps that incorporated information from new explorations. This example of such an addition shows South America in some detail. Greenland, as "Terra Nova," is attached to the Asian mainland, while Japan is not shown at all.

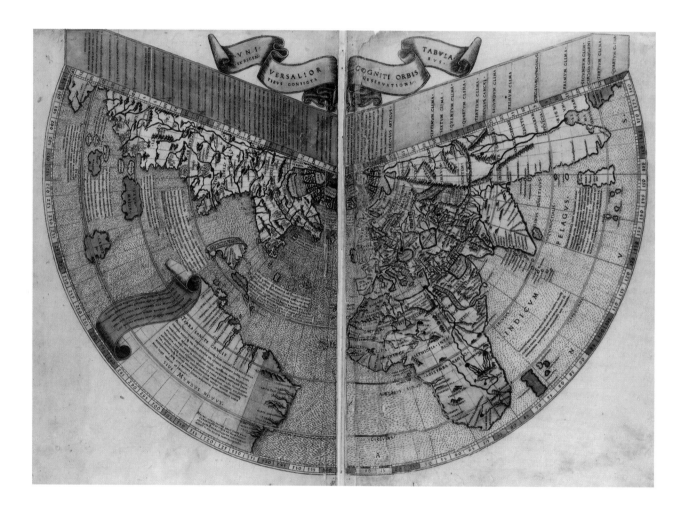

and beauty beyond which lay wilderness. Maps of the New World, drawn during the sixteenth and early seventeenth centuries, exaggerated the number of islands. A few of these achieved mythical or semi-mythical standing, including the Fortunate Islands or the Isles of the Blest just beyond the Pillars of Hercules, and, farther to the west, the "island" of Florida, where Ponce de León expected to locate the Fountain of Youth. Farther west still was the "island" of California, where, according to Sebastian Vizcaino, people, owing to the salubriousness of the climate, lived to extreme old age. In the nineteenth century, the whole New World, despite its continental size, was seen through rosy spectacles as an island Eden, a "Garden of the World," a demi-paradise of enormous natural wealth protected by oceans on both sides, a place where a democratic society could come into existence and flourish, safe from the contaminating miasmas of the Old World.[19]

REALISM WITH IMAGINATION:
A CONCLUDING NOTE

All animals have to be realists in order to survive: their picture of the world may be limited, but it must be correct within that limitation, else they will not know who their enemies are, or how to find the food-rich areas and the water holes. Human beings are different in that we are realists with imagination; and by that I mean the power to envisage something that isn't, or that isn't yet, there. The imagined may be horrible, so much so that it keeps us from taking action. At the other extreme, the imagined may be good. Unlike the evil that is imagined, the good that is imagined energizes: it prompts one to action, to find maps that pretend to show where the Edens and golden cities are, and to make the effort (sometimes heroic) to go there. Or the action may take the form, not of travel, but of construction: what is not there—the good society, the good place—is first conceived in the mind, then built.

Utopian thinking, as Oscar Wilde hinted and as I have argued, is at the core of the cartographic imagination: the map either presents a good place by means of design, including the use of such specialized techniques as contours and shading, or it suggests the routes that must be taken to get there. Maps are not only beautiful. They are also credible, one of their major virtues being their serious effort to conform to reality "out there." But for all their accuracy in locational and other details, they also can be misleading, for they are by their nature ill suited to depicting the dark side of life. The visual and literary artist complements the mapmaker. Artists make no claim to factual accuracy, and for this reason their work risks floating off into fantasy or even into lunacy. On the other hand, good artists—serious artists—even in their most utopian aspirations in matters of design and color, can incorporate, without tortuous artifice, the negativities of life and the world.

And so, if the depiction of reality is the challenge—and by reality, I mean not only what has been or is but also what can plausibly be—then the person best equipped to meet it is one who combines the analytical intelligence of the cartographer with the detailed, multi-hued imagination of the artist.

Figure 9. Claude Dablon (French, 1619–1697), *Lac Superieur et autres lieux ou sont les Missions. . .* (Lake Superior and other places where there are missions . . .), 1672. Copperplate engraving. In *Relation de ce qui s'est passé de plus remarquable aux missions . . .* (Relation of what is the most remarkable at the missions . . .). James Ford Bell Library, University of Minnesota.

The Jesuits were pioneer European explorers in North America. This highly accurate map of Lake Superior was the first to distinguish Green Bay (Baye des Puans) from Lake Michigan (Lac des Illinois). Drawn by two priests, it was engraved to illustrate an annual report of the Jesuit mission in Canada.

NOTES

1. This essay has benefited from the criticism of my colleague David Woodward. Whatever errors remain are of my own making.

2. In this section I have drawn on Cordell D. K. Yee, "Cartography in China," in J. B. Harley and David Woodward, eds., *The History of Cartography*, vol. 2, bk. 2 (Chicago: University of Chicago Press, 1994), 35–202.

3. Even the practical Portolan charts reflect aesthetic aspiration. Witness the range of colors used: black, red, green, blue, yellow, and sometimes gold and silver foil. See Lloyd A. Brown, *The Story of Maps* (New York: Dover, 1977), 139.

4. D. Stanley Tarbell and Ann T. Tarbell, "The Career of Clarence King," *Earth Science History* 4 (1985): 35–36. I wish to thank Robert Dott of the University of Wisconsin–Madison for this reference.

5. Paul Delany, *British Autobiography in the Seventeenth Century* (London: Routledge and Kegan Paul, 1969); Hugh Prince, "Art and Agrarian Change, 1710–1815," in Denis Cosgrove and Stephen Daniels, eds., *The Iconography of Landscape* (Cambridge, England: Cambridge University Press, 1988), 102–3.

6. A. R. Millard, "Cartography in the Ancient Near East," in J. B. Harley and David Woodward, eds., *The History of Cartography*, vol. 1 (Chicago: University of Chicago Press, 1987), 107–16.

7. "The *Forma Urbis Romae* is an important exception to this generalization. It was certainly a civic icon, but also so realistic that it has aided archaeologists in their excavation of Rome." David Woodward, letter to the author, June 15, 1999.

8. Excellent examples are Michael Wolgemut's woodcuts in Hartmann Schedel's so-called Nuremberg Chronicle (1493). The same woodcut of a medieval city recurs, with different captions, as Damascus, Ferrara, Mantua, and Milan. See E. H. Gombrich, *Art and Illusion* (London: Phaidon, 1962), 60.

9. Lelio Pagani, Introduction to *Cities of the World* (Leicester: Magna, 1990), iii–viii. The plates are drawn from Abraham Ortelius et al., *Civitates Orbis Terrarum*, 6 vols., published in Antwerp between 1572 and 1618.

10. A proud "family portrait" of Wisconsin, displaying its handsome peoples and their heirlooms, is David Woodward et al., *The Cultural Map of Wisconsin: A Cartographic View of the State* (Madison: University of Wisconsin Press, 1996).

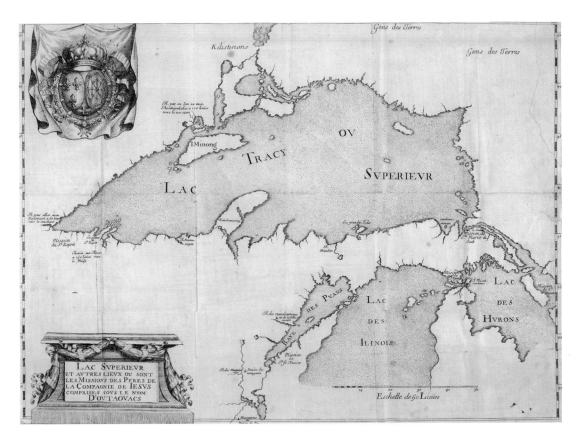

11. Geoffrey J. Matthews, cartographer/designer, et al., *Historical Atlas of Canada*, 3 vols. (Toronto: University of Toronto Press, 1987–93). Planning of the atlas began in 1970. See also Matthew Sparke, "A Map That Roared and an Original Atlas: Canada, Cartography, and the Narration of Nation," *Annals of the Association of American Geographers* 88, no. 3 (1998): 463–95.

12. Contrast the two chapters "Ideal Landscape" and "The Natural Vision," in Kenneth Clark, *Landscape into Art* (New York: Harper and Row, 1976), 109–79.

13. Robert D. Sack, a colleague in geography at the University of Wisconsin–Madison, reminds me that, unlike portraits and landscape paintings, which are the works of individual artists, maps and atlases are group projects. The cartographic group has hardly ever wished to present itself—its world—in a negative light. That aspect of mapmaking began to change in the 1970s, however, when social consciousness drove some cartographers to include the dark side of the world. See, for example, Michael Kidron and Ronald Segal, *The State of the World Atlas* (New York: Simon and Schuster, 1981). Perhaps shaded black-and-white maps best represent a sense of danger. See Mark Monmonier, *Cartographies of Danger* (Chicago: University of Chicago Press, 1997).

14. Oscar Wilde, "The Soul of Man under Socialism," in *The Works of Oscar Wilde* (Leicester: Galley Press, 1987), 1028.

15. Bruce Chatwin, *The Songlines* (Harmondsworth: Penguin, 1988). See also Peter Sutton, "Icons of Country: Topographic Representations in Classical Aboriginal Traditions," in David Woodward and G. Malcolm Lewis, eds., *The History of Cartography*, vol. 2, bk. 3 (Chicago: University of Chicago Press, 1998), 353–416.

16. See Mircea Eliade, *The Sacred and the Profane* (New York: Harper Torchbooks, 1961), for this and other foundation myths.

17. C. P. Fitzgerald, *The Chinese View of Their Place in the World* (London: Oxford University Press, 1964); Bernard Karlgren, *Book of Documents* [*Yü Kung*] (Stockholm: Museum of Far Eastern Antiquities, 1950), 18.

18. David Woodward, "Reality, Symbolism, Time, and Space in Medieval World Maps," *Annals of the Association of American Geographers* 75, no. 5 (1985): 10–21.

19. Howard Mumford Jones, *O Strange New World* (New York: Viking, 1964), 1–34; Henry Nash Smith, *Virgin Land* (New York: Vintage, 1950), 138–50.

Figure 1. Johann Baptist Homann (German, 1663–1724), *Planiglobii terrestris cum utroq hemisphaerio caelesti generalis exhibitio* (Flat globes of the Earth with each hemisphere of the heavens), 1707. Copperplate engraving, hand colored. James Ford Bell Library, University of Minnesota.

Magnificently demonstrating the kind of elaborate decoration often found in antique maps, this example includes small sky charts with zodiacal figures as well as views of both hemispheres. California is represented here as an island.

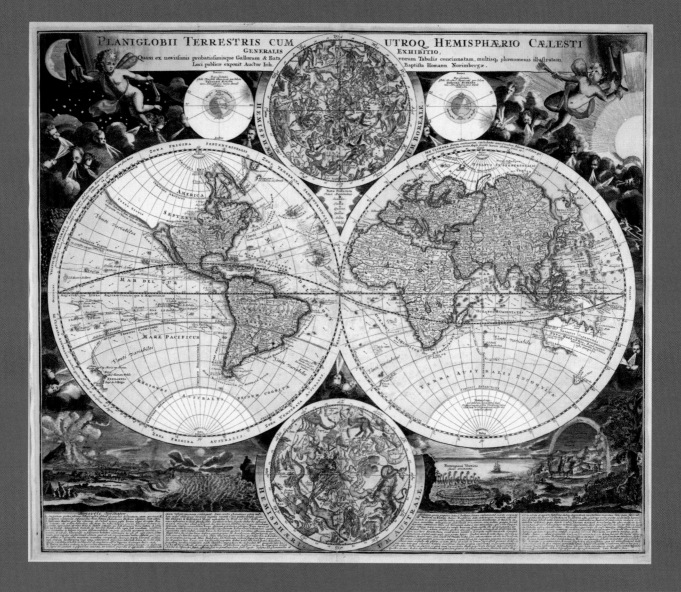

Maps and Art: The Pleasures and Power of Worldviews

Robert Silberman

Who doesn't like looking at maps? They're the wings we use to fly over places, the grid we superimpose on the natural and man-made world. We map what we need to know. —Jerry Saltz [1]

Who doesn't like looking at maps? In *The Anatomy of Melancholy*, published in 1621, the British writer Robert Burton offered this prescription as a cure for that malady: "Methinks it would please any man to look upon a geographical map . . . which insensibly charms the mind with the great and pleasing variety of objects that it offers." He went on to ask, "What greater pleasure can there now be, than to view those elaborate maps of Ortelius, Mercator, Hondius, etc.?"[2]

The maps Burton mentioned are now old and rare. But people today can look with pleasure at ordinary contemporary maps, that is, when they are not trying to find out how to get quickly by car to a meeting, or learn what the next day's weather will be, or locate a place mentioned in a news story. It can be fun simply to wander through a map or, better yet, an atlas full of maps. That activity can turn up unusual place names—Truth or Consequences, New Mexico, and Utopia, Australia. It can lead us to locations heard of but not really known—Pago Pago and Mt. Everest. And it can surprise us with fascinating, if not necessarily useful information—the length and narrowness of Chile (or, for Chileans, the length and breadth of the United States). In a more focused vein, we may wish to review where we have already been by tracing the now-familiar route of last summer's vacation trip. Or we may want to enjoy the sense of anticipation provided by looking at a map of some exotic part of the world where we hope to go.

Historical maps present a world where people can go *only* in their imaginations. "The past is a foreign country," the novelist L. P. Hartley memorably proclaimed in *The Go-Between* (1953). "They do things differently there."[3] Among the things done differently in the past is mapping, but that difference is not absolute. Historical maps involve us today because they offer such a fascinating guide to what has changed and what has not, what was known about the world in former times and what we know now. They do so in a fashion that is at once strange and familiar. Though we may have to puzzle out some differences, getting our bearings so to speak, once we are oriented to the changes in cartography, we can derive a deep satisfaction from using historical maps as windows onto the past.

Many historical maps, the European ones in particular, offer more than just a sense of something old.[4] They have about them the allure and mystery of the age of exploration, when the known world was not the complete world, and fundamental discoveries were still in progress (fig. 1). That sensation is especially strong with hand-drawn

maps, which can suggest new observations recorded directly on the spot (cat. no. 37).

Historical maps often return the viewer to a time when functional artifacts were extravagantly decorated. The age of exploration also witnessed the rise of printing. So the early printed atlases and sheet maps possess the same special character that marks early books in the materials and typography used as well as in overall look and feel. Today, the standard world map in an atlas may be a model of efficient and accurate display of information. But it hardly offers the eye great visual delights. By contrast, older maps often feature beautifully colored and ornamented images—sea monsters cavorting in broad expanses of water, cherubic heads blowing in from the borders to indicate the winds, and vignettes filling all available space in the corners and along the edges with classical figures or exotically costumed native people (fig. 2).[5]

Early maps often reveal a world caught between fact and fiction. Speculative possibilities based on limited experience were commonplace in a time when notions and theories about vast unknown regions had not yet been fully tested. In some maps from the age of exploration, we can see California as an island (fig. 1, p. 26). In others, Antarctica is rendered much larger than its actual size because people thought it must be that large, according to the laws of physics, to balance the landmasses of the Northern Hemisphere (cat. no. 26).

At times, filling in all the spaces on a map became a form of wish fulfillment. As a result, we see oddities such as the Long River (fig. 3, p. 30). This fanciful geographical feature occupied an area that otherwise would have been left blank, and it supported a persistent, erroneous belief in the existence of a Northwest Passage across the North American continent. In much the same way, the waterways that slice through the northern lands in Gerhard Mercator's polar map establish a neat visual order while also making it appear that this is the best of all possible worlds (fig. 4, p. 31). In the Mercator, navigable routes exist precisely where they would be most useful. Since we don't have to rely on these maps as guides, we can delight in such wildly imaginative creations.

Historical maps return us to the time when the Earth could be depicted only to the boundaries of "terra incognita." Of course, the lands never were "incognita" to their residents, who had their own systems of mapping, as a look at a Marshall Island stick chart makes clear

(fig. 6, p. 33). In this respect, quite apart from its subject matter, One Bull's circa 1900 image of the battle between Indian and U.S. forces at the Little Big Horn in 1876 is interesting for the way it combines map and illustration, Native and European forms of representation (fig. 5, p. 32).[6]

Viewing these particular maps reminds us of the fact that, then as now, maps reflect the governing assumptions of the cultures that make them. As the science writer Stephen S. Hall put it, maps are worldviews committed to paper.[7] The T-O map design favored by early Western Christianity provided a schematic model that coupled knowledge of the world and a Christian cosmography (p. 1). It served as the basis for more elaborate and information-rich efforts produced later, such as the Hereford Cathedral *Mappa Mundi* (fig. 7, p. 33).[8] The art historian Juergen Schulz pointed out that a work such as the Hereford functioned as an encyclopedia, a compendium of all knowledge—or what was taken as knowledge—at the time.[9] Eventually, the effort to join geography and religion was abandoned because the tension between the two paradigms was too great, and the claims of science won out.

Even with scientific accuracy at the forefront, strong political and cultural forces are at play in mapping. One obvious example is the placement of the prime meridian at Greenwich, England, determined by the International Meridian Congress, held in Washington, D.C., in 1884, against counterclaims by Cadiz, Paris, and other cities. Earlier the Chinese, confronted by maps that placed Europe at the center of the image, insisted that they be redrawn to give China pride of place. In early representations, the Forbidden Palace was depicted as the center of the world. This is what the art historian Samuel Y. Edgerton, Jr., called the "omphalos syndrome," the tendency of cultures to see themselves as the center of the universe.[10]

Another aspect of mapping with political implications is having the Northern Hemisphere uppermost. Ptolemy, in the second century A.D., placed north at the top of the map because Greek cartographers were more familiar with that part of the world. But in the twelfth century, Arab cartographers such as al-Idrisi actually made maps the other way around, with south at the top, long before twentieth-century artists such as the Uruguayan constructivist Joaquín Torres-García did so for witty, polemical purposes. He advertised his art academy, the School of the South, with a poster featuring South

Figure 2. Joan (Johannes) Blaeu (Dutch, 1596–1673), *Africae nova descriptio* (Africa newly described), 1667. Copperplate engraving, hand colored. In *Le Grand Atlas*. James Ford Bell Library, University of Minnesota.

Africa is represented here, early in the colonial era, with beautiful emblems at the borders that depict various cities and African peoples. The area at the center, largely unknown to Europeans when this map was made, is similarly filled in with decorative devices.

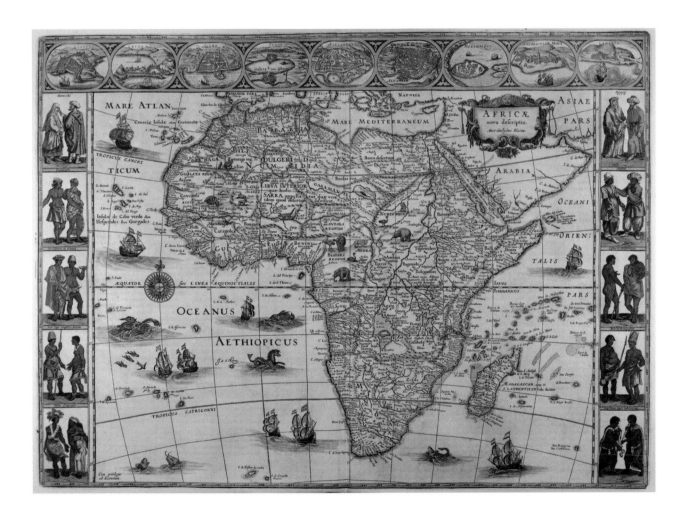

Figure 3. Louis Armand de Lom d'Arce, Baron de Lahontan (French, 1666–1715), *A Map of ye Long River and of some others that fall into that small part of ye Great River of Missisipi...*, 1703. Copperplate engraving. In *New Voyages to North America.* James Ford Bell Library, University of Minnesota.

The Long River is fictional, a creative portrayal of a real river, the Minnesota, shown here flowing into the Mississippi. This map, published in a book recounting Lahontan's voyages, reflects the desire among some mapmakers to account for empty or unknown regions and, more important, to find a Northwest Passage that would allow convenient water travel across North America to the Pacific.

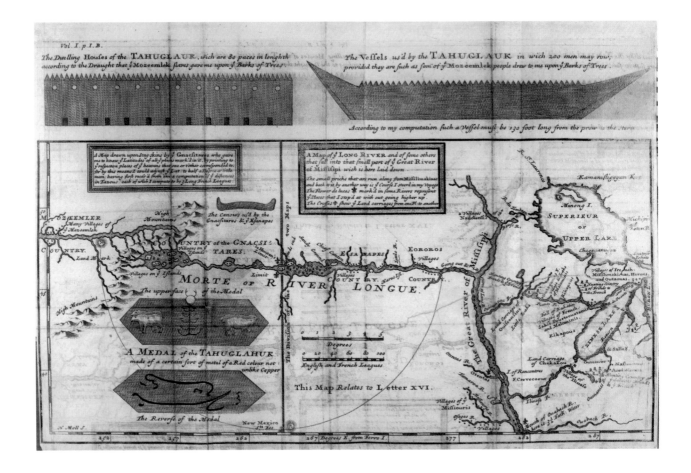

Figure 4. Gerhard Mercator (Flemish, 1512–1594), *Septentrionalium terrarum descriptio* (Description of the northern lands), 1595. Copperplate engraving. James Ford Bell Library, University of Minnesota.

This map of the northern polar region seems authoritative and scientific, yet it is based on considerable wishful thinking. The polar area is shown neatly crisscrossed by routes from Europe to the East that, if they only existed, would make navigation possible and greatly ease transport and travel.

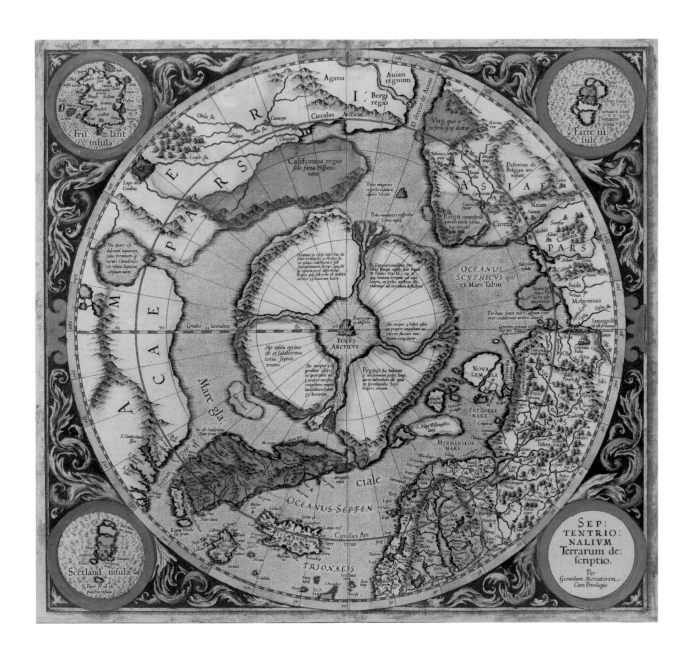

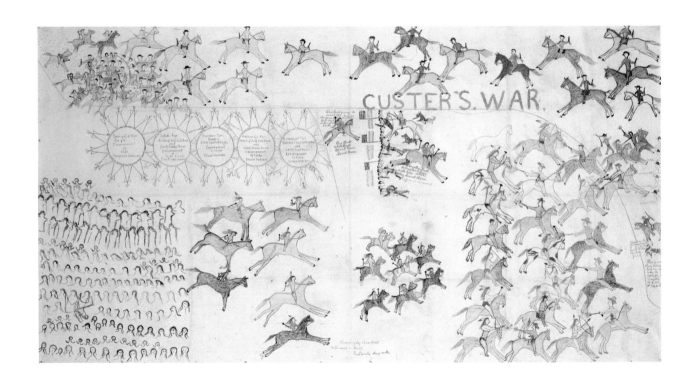

Figure 5. One Bull (Hunkpapa Lakota People, active 19th–early 20th centuries), *Custer's War*, about 1900. Colored pencil and ink on muslin. The Minneapolis Institute of Arts, The Christina N. and Swan J. Turnblad Memorial Fund.

One Bull, who fought in the Battle of the Little Big Horn in 1876, created this representation of it some twenty-five years later. The image is a history painting as well as a map. It shows the destruction of U.S. Cavalry forces led by General George Armstrong Custer by Lakota, Cheyenne, and Arapaho warriors. The map elements are the circles in the center that represent the encampments of the principal Lakota and Cheyenne groups.

Figure 6. Marshall Island stick chart, before 1947. The Field Museum, Chicago.

Such charts were used as tools to teach navigation. The sticks represent water currents.

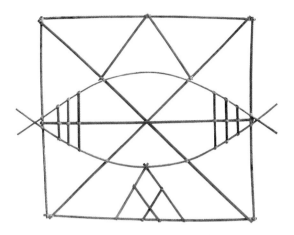

Figure 7. Mappa Mundi, Hereford Cathedral, about 1290–1310. Dean and Chapter of Hereford Cathedral and the Hereford Mappa Mundi Trust.

Medieval *mappamundi* were encyclopedic accumulations of geographical information— both fictional and factual. This one divides the celestial world (considered perfect) from the imperfect terrestrial world. Geography here incorporates legend, mythical peoples, and accounts by those who took part in pilgrimages and the Crusades.

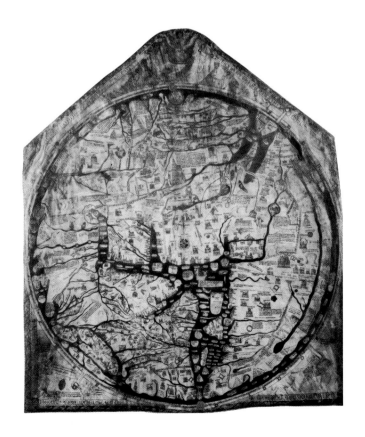

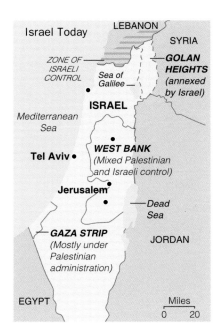

America upside down as an act of defiance against
Europeans.[11]

Geographical maps (for example, shaded-relief
maps) may appear to be relatively neutral. Maps
with political boundaries, however, are often instruments
of power, mirrors of conflict and conquest. Wars are
usually accompanied by a flurry of mapmaking to help the
military plot strategy and conduct operations and to
inform, or misinform, the public.[12] Maps also are essential
in most peace negotiations, for agreement over boundaries
is usually a necessary part of any settlement (fig. 8).

In the Vatican in Rome and in the Palazzo
Vecchio in Florence, there are spectacular spaces where
maps are prominently displayed as wall murals, emblems
of empire. In Italo Calvino's magical novel *Invisible
Cities* (1972), the Great Khan "owns an atlas where all
the cities of the empire and the neighboring realms are
drawn." The book affords that ruler symbolic possession
of the world.[13]

No writer of fiction is more perceptive concern-
ing maps and imperialism than Joseph Conrad. His
1902 novella *Heart of Darkness* reveals an imperialist atti-
tude that the cultural critic Edward Said has described
as "an aesthetic, politics, and even epistemology inevitable
and unavoidable."[14] Yet the imperialist enterprise is set
in perspective by the key figure of Marlow, who recounts
to a circle of listeners the origin of his adventures:

Now when I was a little chap I had a passion for
maps. I would look for hours at South America, or
Africa, or Australia, and lose myself in all the glo-
ries of exploration. At that time there were many
blank spaces on the earth, and when I saw one
that looked particularly inviting on a map (but they
all look that) I would put my finger on it and say,
"When I grow up I will go there.". . . [T]here was
one [,Africa,] . . . the biggest, the most blank, so
to speak—that I had a hankering after.[15]

By the time Marlow arrived there, he says, "It had ceased
to be a blank space of delightful mystery—a white
patch for a boy to dream gloriously over. It had become
a place of darkness."[16] As Conrad later wrote, the formerly
"white heart of Africa" had been ruined by "the vilest
scramble for loot that ever disfigured the history of human
conscience and geographical exploration."[17]

Conrad never entirely lost his youthful
romanticism. But he saw the entire process of exploring,
mapping, and conquering in terms of a shift from
"fabulous geography" to "geography militant" to, finally,
"geography triumphant," the period of colonial domina-
tion and settlement.[18] Antique maps from the age of
exploration can charm us because they offer so much rich
historical information and such visual beauty and because
they communicate in miniature such a vivid sense of
adventure. But they also are relics of geography—and soci-

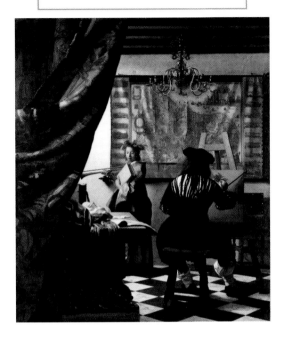

eties—"militant." By the time Cortes's image of Mexico City, that is, Tenochtitlán, had been published in Europe, the actual city had been laid waste by its European conquerors. Maps can be a source of melancholy as well as its cure.

During Joseph Conrad's lifetime (1857–1924), the mysteries on Earth were disappearing. Nonetheless, the process of mapping "terra incognita" continues today, as data produced by a wide range of systems brings us ever more accurate knowledge about the surface of the Earth and what lies beneath it, including the ocean depths. Distant parts of our solar system such as Mars now seem relatively close, well known and well mapped (fig. 22, p. 55). In this century the mapping of outer space has been so transformed that the line between the known and the unknown has been pushed out to almost unimaginable distances, and what now appear as brave new worlds are being revealed in bold new maps.

● ● ●

"Once the mind is tuned to the idea of maps, the eye finds them everywhere," Stephen Hall noted.[19] It is true: we often see what we seek. And this truism about human observation also applies to works of art related to maps and mapping. They, too, can seem to be everywhere.

A history of art could be written that would trace the history of painting in relationship to the history of maps.[20] In the West the history of art from the Renaissance to the rise of modernism does appear to run parallel to the history of cartography.[21] The art historian Svetlana Alpers, for example, has brilliantly analyzed what she describes as the mapping impulse in seventeenth-century Dutch art that links maps and landscape paintings.[22]

Jan Vermeer (1632–1675), a key figure in Alpers's study, painted images of interiors in which maps are prominently featured. In one, a geographer is at work with his compass. In another, an astronomer looks at a celestial globe. And in a third, *The Art of Painting* (about 1665–66, fig. 9), a painter is at work depicting a model, but the border of the map in the background includes landscape images of sites on the map. Vermeer did not simply record typical Dutch interiors. He developed an elaborate parallel between painting and cartography, relating both to the art of representation.

Turning to our own time, we might ask, Which modern artists don't like maps?[23] Without turning the question into an art-historical parlor game, it is apparent that there are many artists for whom maps hold no special appeal as material for their work. Yet a surprising number of twentieth-century artists, some of whom we might not automatically think of in terms of maps, have incorporated maps or maplike elements into their art. Piet Mondrian, an artist generally thought of as inhabiting a world of pure geometric abstraction, is a good example. The title and

Figure 10. Mike and Doug Starn (American, both born 1961), *Sphere of Influence*, 1990–92. Toned Ortho film, silicone, tar, steel, Plexiglas, and pipe clamps. Collection of the artists.

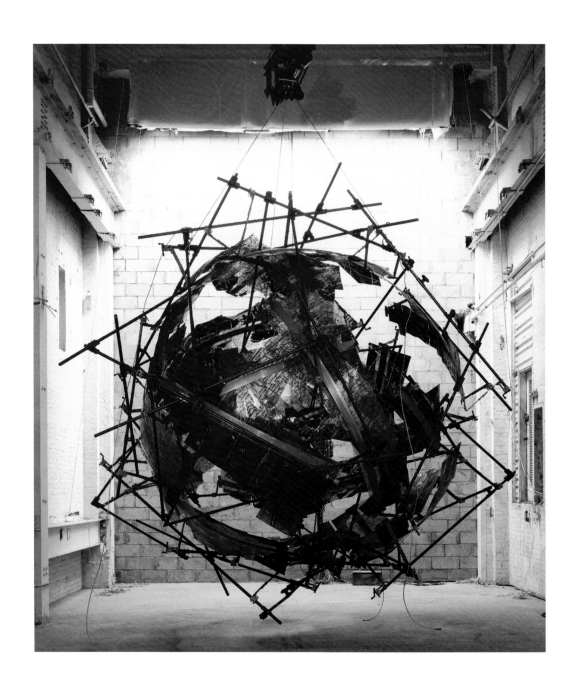

geometrical design of his late painting *Broadway Boogie-Woogie* (1942–43) suggests that he found inspiration in the urban grid as well as in popular melodies.[24]

Maps seem to offer something for everyone. Of course, different artists at different moments light on different aspects of maps and mapping. In some twentieth-century art movements, the use of maps is not necessarily common, yet it is revealing nonetheless. For instance, surrealists of the 1920s and 1930s did not do very many map works. However, there is one surrealist map, published in the Belgian journal *Variétés* in 1929, that shows Paris but no France, North America but no United States. Further, in it the Pacific Islands occupy two-thirds of the Earth, with Easter Island as large as South America and the southern continent itself containing Peru alone. That quirky work offers a worldview as well as a view of the world, neatly expressing surrealist playfulness, contrariness, and ingenuity.[25]

Geographical maps are primarily about the external, physical world. For Joseph Cornell, however, as for the surrealists, maps could suggest an imaginative, exotic universe. In his assemblage boxes, Cornell frequently used maps and star charts (cat. no. 2). As the painter and critic Fairfield Porter wrote, for Cornell the constellations, "as abstractions of the stars, are constructions of the human spirit."[26] A similar fascination with star charts, the zodiac, and imagery from hermetic philosophies and ancient traditions has appeared in a series of contemporary photographic works by the twin brothers Mike and Doug Starn. But the work by the Starns that introduced this particular series was an enormous globe, *Sphere of Influence* (1990–92, fig. 10), constructed in sections developed not from hermetic philosophy and exotic images but from a standard map showing political boundaries. This is one of the most ambitious of all contemporary pieces related to maps, and a perfect demonstration of the creative possibilities maps and globes open to artists of all kinds.

If surrealists made irregular use of maps, pop artists, beginning in the 1950s, led the great revival of maps as an element in art. They took as their starting point the everyday quality of maps, their familiarity and existence in popular culture, outside the art world. The pop artists did not work from rare old maps or historical cartography. Jasper Johns got started on maps when he was given mimeographed copies of the basic U.S. school map by Robert Rauschenberg (who had incorporated maps into his collage/assemblage pieces).

He gave the surface a painterly treatment, turned the state names into bits and pieces of language that sometimes functioned as labels and sometimes approximated purely pictorial forms, and, in the end, deconstructed the map and constructed a painting (fig. 20, p. 51).

Claes Oldenburg made a soft sculpture of the Manhattan ZIP code map in 1966 and then, in 1977, a print showing Chicago as a map where numbers, as a signifying element in map language, seem to have taken over the town (cat. no. 10). Robert Indiana made maps the implement for wicked satire. In the civil rights years, he heaped scorn on the Southern states with maplike images that used his signature style (cat. no. 6). But it was the late Saul Steinberg, a kind of first cousin to the pop artists, who in 1975 created what is probably the best-known and most imitated map work in all of modern art. In presenting the New York (and *New Yorker*) view of the world, he created a comic illustration of the omphalos effect and the power of perspective, showing Manhattan as the center of the universe and not much beyond the Hudson River, or even Tenth Avenue (fig. 11, p. 39). Across the river things get strange, with New Jersey not far from Las Vegas, Washington, D.C., somehow landing near the Mexican border, and the far side of the Pacific popping up on the horizon.

For the artists associated with the high-spirited movement known as Fluxus, which started in New York in the 1960s but had outposts around the world, maps appealed to their expansive, encyclopedic impulse, their delight in common, inexpensive materials, their madcap playfulness, and their interest in art as an activity concerned as much with performance as with object-making. A good-humored example of Fluxus impulses took form when Stanley "This Way" Brouwn created works by asking people on the street to draw directions on small sheets of paper, then assembled the results as a work of art. Since Fluxus members were widely scattered, they used their dispersion as the occasion for mail art and other unusual art forms—as when Robert Watts gathered pebbles sent from around the world into a *Fluxatlas* (1973/1978, cat. no. 15) or when Mieko Shiomi created "spatial poems" that charted positions on maps as the far-flung individuals executed her instructions for performance events: "Write a word or words on the enclosed card and place it somewhere" (cat. no. 13).

Yoko Ono, associated with Fluxus since 1962, has done a number of map and globe pieces, including

participatory works that invite people to make their own maps or redo the globe, thereby presenting their own visions of the world (cat. no. 11). In a somewhat similar vein, Kim Dingle (not connected to Fluxus) made several funny, shrewd paintings based on audience participation. She asked "random Las Vegas teenagers" and other citizens to render accurately an outline of the United States— a shape that proved to be a challenge, both geographically and artistically, for most to draw (fig. 12, p. 40).

The conceptualists and minimalists of the 1960s and 1970s exploited the gridded, rationalistic, mathematical side of maps and mapping. In one of the purest of all map works, Mel Bochner's *Compass: Orientation* (1969, fig. 13, p. 41), the artist employs a floor piece with "E" on the end as a compass arrow to turn the exhibition space into a map by "orienting" it. (In Latin, "oriens" is East.)

The scientism and rationality of maps played right into the conceptualist antipathy toward conventional pictorial systems. Nevertheless, an artist such as Nancy Graves could exploit the duality implicit in maps: working from images of sections of the lunar surface, she created pieces that appeared scientific and impersonal and, at the same time, quite beautiful and all her own (cat. no. 5). As she said: "Mapping encompasses all our significant efforts. It is the most advanced level of conceptual abstraction at the moment."[27]

The conceptual alternative to conventional art often led to a Platonic reliance on language and ideas, as if to create actual objects was, in the language of the day, "too materialistic." But there was another possibility: to go out into the world and make art there. Artists producing so-called earth works from the 1970s to the present, in what has come to be described as a site-specific manner, have turned to maps for obvious reasons: to record and explain their pieces. Maps, as the critic Roberta Smith observed, served these artists well in their effort to escape from the gallery system and the art museum.[28] The maps helped report back to the art world by representing the products of their distant activities. Richard Long, who might be described as a combination sculptor and performance artist, often uses maps (and photographs) to create artworks that document his hikes through nature, artistic performances that might otherwise have no afterlife (fig. 14, p. 42).

Maps also can provide artists with a perfect vehicle for addressing global issues. Recently, political art has often taken a special interest in matters of center and periphery, of the so-called first world and third world. In the work of the late Italian artist Alighiero e Boetti, the use of national-flag emblems to mark nations offers a striking visual twist on the standard political maps. His adoption of this system to denote national boundaries, as seen in *Mappa del Mondo* (1978, fig. 15, p. 43), also directly comments on how nation-states and political boundaries themselves are artificial constructs. This particular work also has a political edge in that Afghani weavers created it, and its making therefore reflects the relationship between the first and third worlds, functional weaving and "non-functional" art, modern art and traditional craft.

In recent years, too, in the United States maps have provided a complex instrument for artists concerned with images of multiculturalism and cultural identity. Houston Conwill, for example, has done a series of installations presenting African-American social and cultural history in the form of maps that are both cosmograms and game boards, records of physical migration and sites of spiritual transcendence (fig. 16, p. 44). Jaune Quick-to-See Smith has, in her *Indian Country Today* (1996, fig. 19, p. 50), responded to the precedent and rarefied artistry of Jasper Johns and to an oppressive history of anti-Indian activities with a combination of painterliness in the drips—of paint, as blood—and of topicality and "realism" in the collaged newspaper clippings. For a Native American especially, what could more clearly symbolize domination than the standard map of the United States, with its political divisions and names representing a total transformation of what a map of pre–European North America would reveal? Here a Native American artist provides her own version of that important cultural artifact in what might be called, borrowing from Conrad, "artistic geography militant."

Many recent works of art that take maps as points of reference incorporate historical maps.[29] In his *AMERICA Invention* (1988–93, fig. 17, p. 44), the German artist Lothar Baumgarten recreated the outline of the 1507 Waldseemüller globe gores (pp. 17–18), the first printed record naming the "New World" as "America" and therefore a perfect symbol of the conquest of these continents as both cartographic and political imperialism.[30] Baumgarten built the piece out of words used by the colonizers to describe the Natives: decimated, exiled, betrayed, romanticized, misnamed. *AMERICA Invention* was but one part of an installation that, in effect, turned the entire Solomon R. Guggenheim Museum into a globe, with the names of

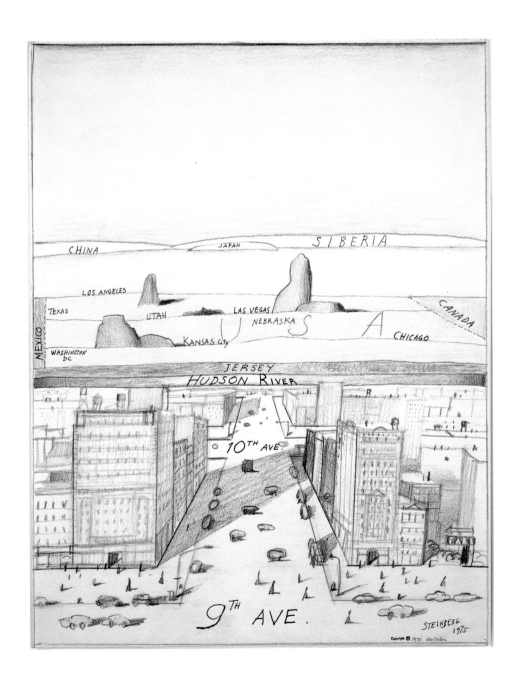

Opposite

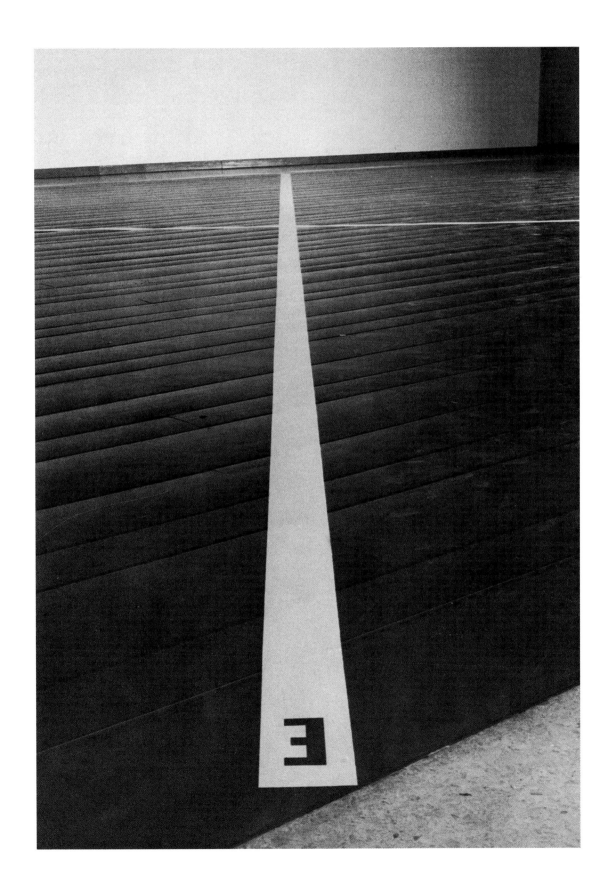

Figure 14. Richard Long (British, born 1945),
*A Line of Night*s, 1981. Map, photography,
and text on paper. Collection Mike and Penny
Winton, Minneapolis.

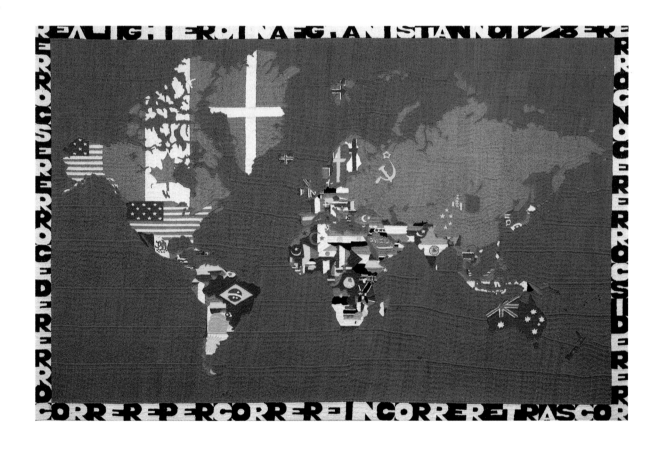

Figure 15. Alighiero e Boetti (Italian, 1940–1994), *Mappa del Mondo*, 1978. Embroidered cloth. Collection PaineWebber Group, Inc., courtesy Sperone Westwater Gallery.

Figure 16. Houston Conwill (American, born 1947), Joseph DePace (American, born 1954), and Estella Conwill Majozo (American, born 1949), *The New Ring Shout*, 1995. Illuminated polished brass and terazzo floor. Federal Office Building, New York.

Conwill creates complex installation works based on maplike models of the African-American world. In this collaborative installation, a cosmography of African-American history is superimposed on a map of New York City.

Bottom

Figure 17. Lothar Baumgarten (German, born 1944), Installation view of *AMERICA Invention*, 1993. Mixed media. Solomon R. Guggenheim Foundation, New York.

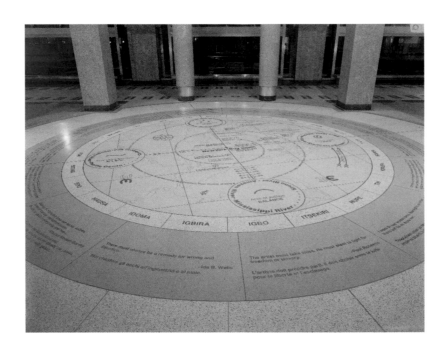

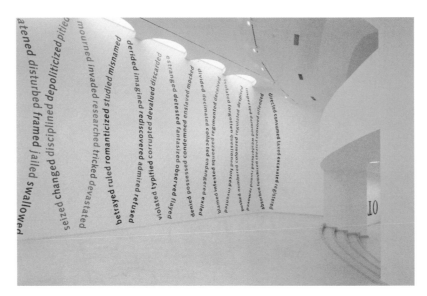

Figure 18. Miguel Angel Ríos (Argentinean, born 1943), *Magallanes en la confusión encontró un océano, #3* (Magellan in the confusion finds the ocean), 1994. Pleated Cibachrome and paint on pleated canvas with pushpins. Collection of the artist, courtesy John Weber Gallery.

Native peoples of the Americas—some their own names in their own languages, some the names assigned them by the Europeans—inscribed around the inside of the rotunda.[31]

Miguel Angel Ríos, an Argentinean artist based in New York City, also engages in a revisionist critique of the Europeans, by using historical maps from the age of exploration to reopen history and introduce a late-twenti-eth-century perspective on the achievement of figures such as Columbus and Magellan. In *Magallanes en la confusión encontró un océano* (Magellan in the confusion finds the ocean) (1994, fig. 18, p. 45), he presents the period of exploration from a modern point of view. He uses carto-graphic, mathematical patterns to give visual energy to the work even as he sets off a kind of cubistic explosion that shatters the sense of geometrical order and leaves the explorer adrift.[32]

Another contemporary artist who uses historical maps to explore contemporary political issues is Joyce Kozloff.[33] During the 1990s, she has been doing a series of map-related works. In *Los Angeles Becoming Mexico City Becoming Los Angeles* (1992–93, fig. 21, pp. 52–53), she creates a collage incorporating images of those two cities, past and present: a nineteenth-century real estate map of Los Angeles, with strips of angels added; a section based on the pictographic maps of Tenochtitlán divided by death's-heads and edged by weeping willows; another Los Angeles section blackened as if smoldering, bordered by funerary urns and a mysterious red river. It is an encyclo-pedic as well as a panoramic treatment of the relationship between the United States and Mexico, which, in Kozloff's words, are shown "coming together, not in an easy way, but discordantly."[34]

●

The world has changed radically in recent years, and global upheavals produce cartographic changes. In the second half of the twentieth century, the end of colonialism in Africa and the collapse of the Soviet Union, to mention but two major changes, have dramatically reshaped the map of the world. Maps and globes showing the former political boundaries and country names for those areas have been rendered obsolete, with no clear indi-cation of when a new order will emerge to make relatively stable mapmaking possible once again. Perhaps the sense of stability was only an illusion, a product, in the United States, of a perspective induced by the fact that the borders

of the Lower Forty-eight have been essentially fixed throughout the twentieth century. Compared to Africa or Europe that is the exception, not the rule.

Given recent major shifts in places such as Germany and the former Yugoslavia, it is not surprising that artists should, increasingly, turn to maps as vehicles for expressing their response to the state of the world. In 1992 the curators Jean Robertson and Craig McDaniel noted that "the list of artworks exploring mapped imagery seems to be expanding exponentially."[35] Now, seven years later, their observation appears to have been validat-ed. Artists have found in maps a powerful instrument for addressing geopolitical issues and a host of other topics, from the environment to AIDS to the human body.

In a world where cyberspace and its virtual reality is rapidly establishing itself as a kind of parallel universe, it is tempting to regard physical reality and the mapping of the physical world as being somehow of secondary importance. As Stephen Hall has observed, mapping offers the perfect metaphor for human cognition. Whether in real space, cyberspace, or mental space, it is *spatial* under-standing that is essential, and that is the domain of maps. The language of mapping has therefore become the terminology of choice for describing new scientific developments. A prime example is the use of the phrase "genetic mapping" for the effort to identify all genes and their locations on chromosomes and make possible a focused analysis of genes with linkages between them and particular human traits or diseases. Yet as recent tragedies such as the accidental NATO bombing of the Chinese Embassy in Belgrade in May 1999 remind us, maps may be artificial constructs, but their use has life-and-death consequences in the real world.

Today, mapping often involves high technology—a scanner in outer space, a medical device that can reach inner space—devices that are light years removed from marking off distance with rods and chains or measuring with a ruler. Atlases and globes and folding paper road maps still exist, as a matter of convenience, but the new generation of maps are computer generated and, often, are first viewed on computer screens. The effects of social and cultural changes surrounding maps and mapping on visual artists, many of them also making the shift to new electronic media, are only beginning to appear. Yet it is possible to suggest that mapping, not representation or realism, has become the master concept in contempo-rary art. To paraphrase Nancy Graves, the tremendous

outpouring of map-related art makes it seem that mapping, broadly defined, now encompasses the most significant concerns of contemporary artists as they consider the world and our place in it.

● ● ●

The three artists commissioned to create works for *World Views*—Mel Chin, Ilya Kabakov, and Laura Kurgan—were invited to produce installations that would relate to maps and mapping and that would be appropriate for the millennial moment. Beyond that, they were left free to be comic or serious, address political issues or ignore them, be elaborately pictorial or purely conceptual, work with the entire world or just a portion of it.

●

MEL CHIN is an artist who always surprises. He has worked in a wide range of forms, with little concern for what they are called. In 1990 he found himself at the center of a controversy concerning a National Endowment for the Arts grant to support *Revival Field*, a project using "hyperaccumulator" plants to leach heavy-metal contaminants from polluted soil. A challenge was raised over whether Chin's work could be considered art or was really a science experiment in disguise. After being vetoed by National Endowment for the Arts Chairman John Frohnmayer, the grant was ultimately approved; and, with the sponsorship of the Walker Art Center in Minneapolis, the project was created in a hazardous-waste site in St. Paul.**36**

Chin has never shied away from politics or unconventional art making. His works are often concerned with the environment and with issues related to global politics. He has frequently done works related to maps and mapping, a subject he knows well. The simple expressive elegance of *Inescapable Histories* (1988) makes it a brilliant vehicle for conveying a political point. A small piece of Hebron marble in the shape of Israel/Palestine and a piece of raw wool resembling a sling are attached to the wall with an olive-wood peg and used to inscribe a circle in the surface of the wall—a circle whose ends do not meet. David and Goliath, the rock throwing of the *intifada*, Israelis and Palestinians, and the difficulty of bringing opponents together are all neatly represented—with the map as the key element.**37**

Chin's piece for the present exhibition reflects his interest in engaging contemporary political issues as well as in one aspect of mapping that is too often over-looked: there are groups, such as the Kurds, whose existence is not recognized on most maps because they do not possess political statehood. Maps abstract as well as represent; they reflect selected aspects of the world in a schematic way. So except when they are specifically singled out for recognition, as in a newspaper map show-ing the settlements or population density of Kurds in Turkey or Iraq, Kurds have no cartographic existence.**38**

For a major 1991 piece, *Degrees of Paradise: The State of Heaven*, Chin commissioned Kurdish weavers to create a large rug that was suspended overhead. This map of the heavens was based on satellite telemetry of the global cloud cover, and it referred to the Persian cultural tradition of paradise carpets. Yet it was meant as a guide to ozone depletion, for the final projected work was to be unwoven or rewoven according to changes in the Earth's ozone layer. In a connected gallery space, video monitors played multidimensional fractal images of ever-changing cloud formations, the high-tech, modern version of sky mapping.**39**

In thinking about what he wanted to do for *World Views: Maps and Art*, Chin at first entertained the idea that rugs could be turned into three-dimensional representations that would, in effect, bring a now frag-mented, repressed Middle Eastern civilization symbolically back to life. The viewer would pass through the gallery as if through a magical world. Then, Chin fastened on the idea of creating a video game that would present an appropriately unreal vision of a fantastic civilization based on the carpet designs. As the rug embodies the civilization, its design serving as a kind of map, so the game contains the civilization as a fictive world that can be made visual and convincing in the unreal but realistic realm of a computer screen. Video games, so often associated with mindless entertainment or dangerous participation in vicarious violence, are here turned into a pleasurable but serious involvement with an important political matter; art and popular culture are deployed to raise consciousness through a lively experience.

As a maker of so-called public art, Chin often uses public meetings as an element in the planning and development of his works. He also has organized col-laborative efforts such as the GALA Committee, a group that created artworks placed within the sets of the televi-

sion series *Melrose Place* (cat. no. 4).[40] For *World Views*, he assembled a Mission Impossible-esque team of computer-game experts, artists, and others, who call themselves the KNOWMAD Confederacy, to create the video game that is at the center of the installation.

The work, itself entitled *KNOWMAD* (cat. no. 17), attempts to alert viewers to the power of imagination, both their own and that of others. It is an homage to the Middle Eastern women who make rugs and to the nomadic heritage many of them represent, a heritage whose existence is threatened by modern civilization. To be nomadic, Chin insists, is not to be *without* a place but to define a sense of place through action and imagination. As he puts it, "Motion plus Action equals Place (i.e., MAP)." In paying tribute to the survival of these cultures and to the power of such ideas, Chin and the KNOWMAD Confederacy also pay tribute to art and artists, who Chin, a bit of a peripatetic figure himself because of his widespread projects, regards as nomads of the imagination.

ILYA KABAKOV, the most important artist of his generation in what was then the Soviet Union, supported himself as a book illustrator while working independently as a leader of an alternative, underground art scene in Moscow. His elaborate installations and albums (drawings and texts that present fictional narratives) earned him a reputation among Western curators and critics. Since his move to the West in 1988, he has traveled around the world, creating installations notable for their complexity, imaginative vitality, and artistic skill.[41]

Maps or maplike works appear occasionally in his work.[42] But Kabakov is really a cartographer of consciousness, charting the social and psychological effects caused by the Soviet system he lived under for so long, often by representing the material conditions of Soviet life.

Kabakov creates what he calls "total installations," environments in which the position of the viewer is often crucial. In *The Toilet*, a 1992 installation for *Documenta*, the periodic international exhibition in Kassel, Germany, he built a version of a provincial public restroom in which exhibition visitors found signs, as they walked through it, that homeless people were using it as a residence. In *10 Characters* (1988), a Soviet-style collective apartment captured in exhaustive detail, he fashioned spaces that viewers peered into, as if peeping into others' rooms.

Another characteristic feature of Kabakov's art is the creation of surrogates. In *Incident at the Museum, or Water Music* (1992), he created an entire exhibition of paintings by a fictitious artist that was then installed so as to make it seem that the gallery suffered from a horrific number of leaks, with containers spread around to catch dripping water. A droll joke indeed. As the philosopher and critic Boris Groys has observed, Kabakov's use of these fictitious "fronts" enables him simultaneously to present work and separate himself from it, establishing an ironic distance between himself and the art and defining an array of viewpoints.[43]

The Globe in a Different Topographical System (cat. no. 16), his installation for *World Views*, is the first realized version of many proposals included in *The Palace of Projects*, an installation piece he produced with his wife, Emilia, that was first exhibited at The Roundhouse in London in 1998. *The Palace* presented ideas for projects as the fantasy life of Gogolian urban dwellers, including many images of flight or alternative realities.[44]

The worldview of *The Globe in a Different Topographical System* is, purportedly, that of "O. Kats," a New York accountant. The installation presents the world as three continents occupying three levels on a tiered structure situated in a corner of the gallery. For O. Kats, Russia is regressive, existing as a "gigantic drop 'downward'" relative to Europe; the movement from Russia to Europe to America is one of ascent and progress. America, on the top level, is identified with a futuristic energy and motion, "like inside a gigantic cabin of a gigantic spaceship." The viewing platform in *The Globe* offers an appropriately formal yet detached vision of the world. The gallery spectator sees the tiered structure from atop a series of steps, and the distanced and raised vantage point creates an ambiguous position for regarding an ambiguous work.

In a separate statement, Kabakov adds to and cuts through this ambiguity. He introduces the same "psychological" geography that includes America as the final stage and recounts how he experienced this feeling on a journey from Frankfurt to New York. Kabakov then adds a last line, in his own recollection, that calls the entire Katsian project into question and gives the game away: "When I told my friend about my state, he thought about it and said that he experiences something similar, but he always thought it was some sort of defect in his vestibular apparatus." Instead of a sensation of freedom that reveals a grand perspective on the contemporary world, Mr. Kats may be experiencing the results of a medical problem.

48

LAURA KURGAN, born in South Africa but now a resident of New York City, was trained as an architect and teaches architecture at Princeton. She has worked primarily as a teacher and an artist creating installations that explore architectural fundamentals such as space, place, and representation. Her art addresses issues related to mapping in ways that seem contemporary, both technically and conceptually. She has done a number of works entitled *You Are Here* that use Global Positioning System (GPS), the satellite-based technology that can provide data "fixes" for locations anywhere on Earth. But that's just it: Kurgan's work poses questions about "information drift," the disjunctions (i.e., the "plus or minus" factor) between what the system promises and what it can actually deliver.[45]

People may be familiar with GPS from its uses in car-guidance systems or in surveying and archaeology, but it was first developed by and for the military. The United States government has refused to permit public distribution from such systems of more accurate data, supposedly to prevent enemies from being able to use it for targeting. Kurgan has exploited this situation by creating installations that show—using data tailored to the specific museum or gallery location—how the tolerances built into the system make any precise fix impossible no matter how accurate the data.

In spite of the ballyhooed precision of GPS, Kurgan insists, "These days, orienting yourself is becoming increasingly disorienting." In the *You Are Here* works, she uses GPS to create drawings by moving through spaces and then plotting the points that trace her path. These images dramatize "the draft and disorientation at work in any map or any architecture—especially the architecture of information." As Kurgan wryly notes, we are all experiencing "a location crisis": the "datascape" we find ourselves in promises a clear answer to the question "Where am I?" but instead "opens new questions that challenge the most basic ways we think about space."[46]

Shifting away from GPS and toward satellite surveillance in her recent work, Kurgan has explored a new form of the same problems related to information, resolution, and the representation of specific locations. With data supplied by up-to-date commercial satellites, a dream of absolute precision is once again betrayed by the medium itself. And the existence of virtually infinite data has its own unfortunate consequences. The maximum amount of detail cannot tell us everything.

The photographic image breaks up just when we get close to understanding what it is showing.[47]

In Kurgan's work for this exhibition, *Spot 083-264, June 3, 1999, Kosovo* (cat. no. 18), the image begins by looking like an abstraction, starts to come into focus in a series of images that probe the data, and then returns to abstraction, since the pixels lead us toward a comprehensible representation and then away from it.[48] So knowledge—and the power that comes with such knowledge, the power to observe voyeuristically or to investigate the world for evidence of war crimes (if not missiles)—remains limited by the means of perception. Maps, and related tools for gathering and representing visual information about the world, are not perfect. Views of the world seduce us with the promise of knowledge that they do not always provide.

●

The works in *World Views* by the KNOWMAD Confederacy, Ilya Kabakov, and Laura Kurgan are provocative reminders of the artistic possibilities that maps offer as we approach the millennium, and of the changing circumstances—technological, political, social—that affect our view of the world as seen through maps. These works are worthy heirs to the great tradition of exploration and cartography that produced the maps of "Ortelius, Mercator, Hondius" and the equally great tradition of artistic use of maps, from Vermeer to the present. As Robert Burton might have wished, they exercise the viewer's mind and eye, instruct us about the pleasures and dangers of worldviews, and remind us once again about why people like maps—and art.

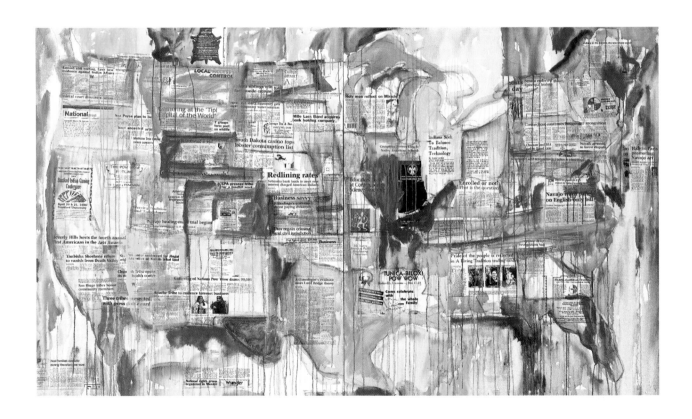

Figure 19. Jaune Quick-to-See Smith (Native American, Cree-Flathead-Métis-Shoshoni, enrolled member of Confederated Salish and Kootenai Nation, western Montana, born 1940), *Indian Country Today*, 1996. Acrylic and collage on canvas, diptych. © Jaune Quick-to-See Smith, courtesy Steinbaum Krauss Gallery, New York.

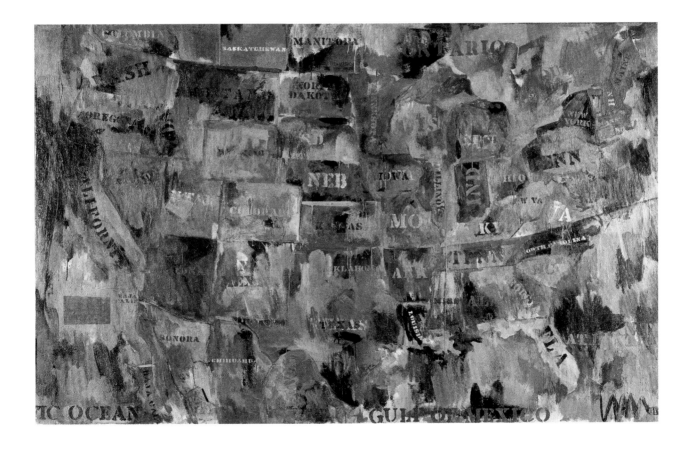

Overleaf

NOTES

1. Jerry Saltz, "Guillermo Kuitca's Human Touch," in *A Book Based on Guillermo Kuitca* (Amsterdam: Contemporary Art Foundation, 1993), 138.

2. Robert Burton, "Exercise Rectified of Body and Mind," in Holbrook Jackson, ed., *The Anatomy of Melancholy* (1621; repr. London: J. M. Dent and Sons, 1932), Partition 2, 89.

3. L. P. Hartley, *The Go-Between* (London: Hamish Hamilton, 1953), 9.

4. For the history of cartography, see the title in the Selected Bibliography edited by J. B. Harley and David Woodward. For the age of exploration, see the titles by Rodney W. Shirley and Peter Whitfield. For America, see the titles by Seymour I. Schwartz and Ralph E. Ehrenberg, David Turnbull, Mark Warhus, and John Noble Wilford.

5. David Woodward has rightly warned against the narrow definition of the term *work of art* that leads to the frequent equation of art "with maps' ornamental elements and nothing more." Woodward, Introduction to Woodward, ed., *Art and Cartography: Six Historical Essays* (Chicago: University of Chicago Press, 1987), 2. On the political implications of decorative elements, especially the European representations of Native Americans, see the titles in the Selected Bibliography by J. B. Harley, Alice C. Hudson, and Michael J. Shapiro.

6. There is a danger in making aesthetic objects out of cultural objects designed to play a different role. It is easy to regard a Marshall Island stick chart, for example, as a kind of modern sculpture before the letter, if one considers only its form and not its function. The problem becomes complicated in the case of other non-Western forms related to mapping, such as Navajo sand paintings or the Australian aboriginal Dreamings, because in the twentieth century these have been turned into superb works designed to be marketed to art collectors—rugs in the case of Navajo images, acrylic paintings in the case of the Dreamings. The question of the status of the original works is handled with great intelligence by David Woodward and G. Malcolm Lewis in their introduction and concluding remarks in Woodward and Lewis, *The History of Cartography: Cartography in the Traditional African, American, Arctic, Australian, and Pacific Societies*, vol. 2, bk. 3 (Chicago: University of Chicago Press, 1998), 1–10, 532–37. See also Lewis's section "Maps, Mapmaking, and Map Use by Native Northern Americans," 51–182, and the contributions by others in the same volume.

7. Stephen S. Hall, *Mapping the Next Millennium: The Discovery of New Geographies* (New York: Random House, 1992), 21. See also Denis Wood with Jon Fels, *The Power of Maps* (New York: Guilford Press, 1992).

8. The late Öyvind Fahlström deliberately created a modern version of these world maps, jam-packed with information and imagery devoted to world resources and the state of global capitalism. See his *World Map* (1972) in *Öyvind Fahlström*, exh. cat. (New York: Solomon R. Guggenheim Museum, 1982), 74–75. He also did a map of the United States that takes an approach similar to the one Alighiero e Boetti used in his map works, but with highway advertising signs instead of flags filling the silhouette of the country. See Marie-Ange Brayer, "Mesures d'une fiction picturale: La carte de geographie," *exposé* 2 (1995): 20.

9. Juergen Schulz, "Maps as Metaphors: Mural Map Cycles of the Italian Renaissance," in Woodward, ed., *Art and Cartography,* 114. The encyclopedic impulse in mapping, the gathering and ordering and assigning of (geographical) data, helps account for the manner in which, as Robert Darnton has observed, the French encyclopedists, following Francis Bacon, regarded their activity as a mapping of knowledge (Darnton, *The*

*Great Cat Massacre and Other
Episodes in French Cultural
History* [New York: Basic Books,
1984], 194). Mapping, even
then, was a master metaphor for
comprehension.

10. Samuel Y. Edgerton, Jr.,
"From Mental Matrix to
Mappamundi to Christian Empire:
The Heritage of Ptolemaic
Cartography in the Renaissance,"
in Woodward, ed., *Art and
Cartography,* 26.

11. For an illustration of the
al-Idrisi, see Plate 3 in *Art and
Cartography,* ed. Woodward.
For Torres-García, see the repro-
duction of his 1943 drawing
Inverted Map of South America in
Robert Storr, *Mapping,* exh. cat.
(New York: Museum of Modern
Art, 1994), 9.

12. See Michael J. Shapiro,
*Violent Cartographies: Mapping
Cultures of War* (Minneapolis:
University of Minnesota
Press, 1997).

13. Italo Calvino, *Invisible Cities,*
trans. William Weaver (New York:
Harcourt Brace, 1974), 135.
The book also contains "the
maps of the promised lands visit-
ed in thought but not yet discov-
ered or founded: New Atlantis,
Utopia, the City of the Sun,
Oceana, Tamoe, New Harmony,
New Lanark, Icaria," 164.

14. Edward W. Said, *Culture and
Imperialism* (New York: Alfred A.
Knopf, 1993), 24.

15. Joseph Conrad, *Youth: A
Narrative and Two Other Stories*
(Garden City, N.Y.: Doubleday
Anchor, 1959), 73. *Heart
of Darkness* is included in
this volume.

16. Ibid.

17. Joseph Conrad, "Geography
and Some Explorers," in
Late Essays (London and
Toronto: J. M. Dent and Sons,
1926), 24, 25.

18. Ibid., 4, 8, 13. As Martin
Bruckner has recently demon-
strated, the map of the United
States played a major role
as an icon of patriotism in the
nineteenth century. See

Bruckner, "Lessons in Geo-
graphy: Maps, Spellers, and
Other Grammars of Nationalism
in the Early Republic," *American
Quarterly* 51, no. 2 (June 1999):
311–43. The history of the
nation in that period is well told
by maps as a sequence from
exploration through military
"adventures" to the building of
railroads and the sale of real
estate—often in rapid succes-
sion. In Minnesota, for example,
the shift from territory to
statehood, from a few counties
to a dense checkerboard,
took very little time.

19. Hall, *Mapping the Next
Millennium,* xii.

20. See Woodward, ed., *Art and
Cartography.* In a related
topic, as Robert Storr points out
in *Mapping* (10–11), maps
play a small but lively role in
mainstream movies such as
Casablanca (1942). For an
examination of how movies use
maps in an ideological fashion,
see Ella Shohat, "Imaging Terra

Incognita: The Disciplinary Gaze
of Empire," *Public Culture* 3,
no. 2 (spring 1991), 41–70. An
important non-Hollywood film
based upon maps is Peter
Greenaway's *A Walk through H*
(1978); the narrative is con-
structed around the director's
own map art. One source of my
own interest in maps was Jean
Renoir's famous World War I
prison-escape film, *Grand Illusion*
(1937), which begins with a prob-
lem of interpretation concerning
a surveillance photograph and
ends with two escapees consult-
ing a crude map and trying to
determine where the Swiss
border (and safety) is. One says,
"It's just that German snow
and Swiss snow look pretty much
the same!" The other replies,
"Don't worry, there's a genuine
man-made frontier right there,
even though nature doesn't give
a damn."

Maps are just as common in
books as in films as a means of
giving readers a sense of the
spatial situation, be it in *The
World of Pooh* (cat. no. 55),
Treasure Island (cat. no. 56), or
Faulkner (cat. no. 53). To the
best of my knowledge, there has
been no extended study of

literary maps. But see Anne McClintock, "Maidens, Maps, and Mines: The Reinvention of Patriarchy in Colonial South Africa," *South Atlantic Quarterly* 87, no. 1 (winter 1988), 147–92, for a discussion of the map in H. Rider Haggard's *King Solomon's Mines* (1885), in which the features of the landscape present an unmistakable diagram of the female body that, as McClintock notes, is "explicitly sexualized," 150. And for a fascinating discussion of the relationship between writing and cartography in early modern France, see Tom Conley, *The Self-Made Map* (Minneapolis: University of Minnesota Press, 1996). During the age of exploration, the language of mapping, exploration, and the New World permeated English literature, whether in Shakespeare's *The Tempest*, Andrew Marvell's "Bermuda," or the poems of John Donne.

21. From the Renaissance to the rise of modernism, maps—and globes—appear in many works of art, most often as icons of power. Maps and globes are standard props in portraits of rulers, statesmen, and generals. An early example of this practice occurs in Hans Holbein's *The Ambassadors* (1533), where the globe serves as a symbolic element that contributes to the characterization in the portrait.

22. Svetlana Alpers, *The Art of Describing: Dutch Art in the Seventeenth Century* (Chicago: University of Chicago Press, 1983). It is important to note that Alpers does not accept an equation between the perspectival grid in painting and cartographic grids, 137–39.

23. For modern art related to maps, see the titles in the Selected Bibliography by Marie-Ange Brayer, Peter Fend, Jean Robertson and Craig McDaniel, Roberta Smith, and Robert Storr.

24. A contemporary example is Deborah Butterfield, the American artist known for her sculptures of horses. In 1980, when she was invited to make a work for the Israel Museum in Jerusalem, she felt compelled to respond to the geopolitical tensions in the Middle East. The result was a somewhat unusual work for her, in that the pattern on the horse's sides resembles forms on a map. See *Horses: The Art of Deborah Butterfield*, exh. cat. (Coral Gables, Fla.: Lowe Art Museum, 1992), 83.

25. The surrealists looked to Lewis Carroll as a spiritual ancestor, and to *Alice in Wonderland* and *Through the Looking Glass* as holy texts (for nonsense and metaphysical play, that is). But where maps were concerned, the surrealists found their true ancestor in the Carroll of "The Hunting of the Snark," in which the crew applauds the bellman for giving them a map "they could all understand because it was totally blank," and of *Sylvie and Bruno Concluded*. In the latter, the German professor tells of a map drawn at one-to-one scale but not yet unfolded because the farmers objected that it would block out the sun, and so "now we use the country itself, as its own map, and I assure you it does nearly as well." That wonderfully ridiculous idea is echoed in the most famous of all twentieth-century tales of map madness, Jorge Luis Borges and Adolfo Bioy Casares's supposed recounting of the excerpt from J. A. Suarez Miranda's *Travels of Praiseworthy* Men (1658), in which a similar map of the territory is made at the identical scale of the empire itself; later generations find it cumbersome,

so only fragments remain in the Western deserts. Jorge Luis Borges, "Of Exactitude in Science," in *A Universal History of Infamy*, trans. Norman Thomas di Giovanni (New York: Dutton, 1972), 141.

26. Porter quoted in Dawn Ades, "The Transcendental Surrealism of Joseph Cornell," in Kynaston McShine, ed., *Joseph Cornell*, exh. cat. (New York: Museum of Modern Art, 1980), 32.

27. Graves quoted in Roberta Smith, *4 Artists and the Map: Image/Process/Data/Place*, exh. cat. (Lawrence, Kans.: Spencer Museum of Art, University of Kansas, 1981), 11.

28. Ibid., 6.

29. Among the most interesting of all recent works inspired by maps are those by the Swedish artist Bertil Vallien. Several suggest archaic or prehistoric maps. Yet the original impetus for the series came from an image Vallien thought was a human face but turned out to represent an aerial-surveillance photo of a bombed village in Iraq. Of such interpretive quandaries and expressive equivocations are maps and map art made. See *Area II*, exh. cat. (Borgholm, Sweden: Galleri Kamras, 1991.)

30. See *AMERICA Invention: Unsettled Objects*, exh. cat. (New York: Solomon R. Guggenheim Museum, 1993). For a discussion that includes many of Baumgarten's map works, see Marie-Ange Brayer, "Lothar Baumgarten," *Forum International* 4, no. 19 (October–November 1993): 103–111.

31. The linguistic dimension of mapping as a form of domination is also highlighted in the Irish playwright Brian Friel's 1981 play *Translations*, in which the English military surveys Ireland in 1833 for military and taxation purposes, changing Gaelic names to English ones on the maps. See also Paul Carter, *The Road to Botany Bay: An Exploration of Landscape and History* (New York: Alfred A. Knopf, 1988), which begins with a chapter analyzing Captain James Cook's Australian place names. The United States reflects the survival and imposition of cultures in its frequent juxtaposition of Native American and European names (e.g., Minnesota and St. Paul).

32. Ibrahim Miranda has argued that in Cuba maps have a special significance for artists because a map serves so well as an icon of identity. See Miranda, "Notas Para Uma Ilha Que Sonhou Ser Um Continente (Notes for an Island Which Dreamt of Being a Continent)," *Ninth Exhibition of Prints, City of Curitiba*, exh. cat. (Curitiba, Brazil: Fundação Cultural de Curitiba, 1993), 171. (I thank Patricia McDonnell for calling this book to my attention.) Certainly, maps have played a major role in Latin American art. Guillermo Kuitca, one of the major artists of our time using maps, charts exile and displacement in maps of places he has never been. Carlos Capelan, a Chilean residing in Sweden, often uses soil as a material in symbolic male portraits drawn over historical maps—of an inverted South America, of Scandinavia, of both hemispheres.

33. See *Joyce and Max Kozloff: Crossed Purposes*, exh. cat. (Youngstown, Ohio: Butler Institute of American Art, 1999).

34. Kozloff quoted in Moira Roth, "Conversation with Joyce Kozloff, *Joyce and Max Kozloff*, 19.

35. Jean Robertson and Craig McDaniel, *Exploring Maps*, exh. cat. (Terra Haute, Ind.: Turman Art Gallery, Indiana State University, 1992), 46.

36. For the former chairman's account, see John Frohnmayer, *Leaving Town Alive: Confessions of an Arts Warrior* (Boston and New York: Houghton Mifflin, 1993), 237–38. He admits that he exercised his veto over the Chin proposal for "the wrong reason . . . to establish my right to veto," 238. An ongoing project, *Revival Field* has been "installed" in various locations.

37. See Peter Boswell, *Viewpoints: Mel Chin*, exh. brochure (Minneapolis: Walker Art Center, 1990). Another of his many other pieces related to mapping, *The Operation of the Sun through the Cult of the Hand,* installed at the Loughelton Gallery in New York in 1987, was a complex installation that presented a celestial system based on both Greek and Chinese alchemic, mythic, and scientific traditions. See also Benito Huerta, ed., *Inescapable Histories: Mel Chin* (Kansas City, Mo.: Exhibits USA, 1996).

38. Chin's thinking about these matters was influenced by Robert D. Kaplan, "The Coming Anarchy," *Atlantic Monthly* 273, no. 2 (February 1994), 44–76. Kaplan discusses West Africa— "There is no other place on the planet where political maps are so deceptive," 46—and in a section entitled "The Lies of Mapmakers," Turkey, Iran, and the other countries that incorporate territories where the Kurds are predominant. Kaplan argues that "The Kurds suggest a geographic reality that cannot be shown in two-dimensional space," 70. He concludes that in the future, the world map will be "a protean cartographic hologram . . . an ever-mutating representation of chaos," 75.

Figure 22. The Topography of Mars Revealed by Mars Orbiter Laser Altimeter Measurements Taken through April 15, 1999, 1999. Laser print on paper. Mars Orbiter Laser Altimeter Science Team.

39. See Thomas McEvilley, "Explicating Exfoliation in the Work of Mel Chin," *Soil and Sky: Mel Chin*, exh. cat. (Philadelphia: Fabric Workshop, 1993), 26–29.

40. See Tom Finkelpearl and Julie Lazar, *Uncommon Sense*, exh. cat. (Los Angeles: Museum of Contemporary Art, Los Angeles, 1997). See also "Primetime: Contemporary Art," *Art by the GALA Committee as Seen on Melrose Place,* auction cat. (Beverly Hills: Sotheby's), November 12, 1998.

41. On Kabakov, see Amei Wallach, *Ilya Kabakov: The Man Who Never Threw Anything Away* (New York: Harry N. Abrams, 1996); and Boris Groys, David Ross, and Iwona Blazwick, *Ilya Kabakov* (London: Phaidon, 1998).

42. The album *Anna Petrovna Has a Dream* (1972–75) playfully traces the existence of the title character's best friend, as in a sheet labeled "Olga Markovna had lots of acquaintances at the seashore," which provides a map showing the location of each individual along the coast (which takes the form of a teapot), neatly numbered and cued to a legend. See Wallach, *Ilya Kabakov*, 128–29.

43. Boris Groys, "The Movable Cave, or Kabakov's Self-Memorials," in Groys, Ross, Blazwick, *Kabakov*, 35.

44. Flight, as both aerial travel and as escape, is a recurring subject in Kabakov's work. In the albums we see grand vistas and people linking their arms and floating into the sky. And perhaps the best known of all the installations is *The Man Who Flew into Space from His Apartment* (1988). It shows a room that is supposedly the dwelling of a man who has launched himself into outer space with a bizarre slingshot-like contraption. See Wallach, *Ilya Kabakov*, 196–99.

45. In 1994 Kurgan did *You Are Here: Information Drift* at the StoreFront for Art and Architecture in New York. Her related artist's statement is in *Assemblage 25* (December 1994): 16–43. In 1995 *You Are Here: Museu* was included in the inaugural exhibition at the Museu d'Art Contemporani de Barcelona. See Laura Kurgan and Xavier Costa, eds., *You Are Here: Architecture and Information Flow*, exh. cat. (Barcelona: Museu d'Art Contemporani de Barcelona, 1995). And in 1996, she exhibited *You Are Here: One Mile Zone* at the Banff Center for the Arts, Alberta, as part of the exhibition *The Space of Information*.

46. Laura Kurgan, *You Are Here: Architecture and Information Flow*, 121, 122, 130, 131.

47. This might be called the *Blow-Up* effect, after Michelangelo Antonioni's 1966 movie about a London photographer who inadvertently records a murder but cannot decipher the image, which eventually dissolves in the process of successive enlargements.

48. In 1997 Kurgan's *Close up at a Distance*, an installation using declassified high-resolution satellite imagery, was included in *The Art of Detection: Surveillance in Society*, an exhibition at the MIT List Visual Arts Center.

The Globe in a Different Topographical System

As is well known, the Earth is round. This fact was first postulated, and then sea and air travelers confirmed it. In this "simple" geography, the various countries of the world adjoin one another, being arranged, so to speak, flatly over the entire surface of the "globe" (obviously, differing from one another in terms of mountain height, relief, and so forth). But the "geography" that will be discussed here cannot be verified with topographical or other physical measurements. This kind of geography can best be called a "mental" or psychological one. And although there isn't a physical means for measuring it yet, it is no more cogent or probable than the current and conventional geography, even though it is relatively recent.

Functioning as the objects of correlation in this mental geography are not continents but instead such mental spaces (in this case, analyzed by us) as Russia, Europe, and North America. (The author doesn't have a sufficiently clear impression of other spaces.) All three of these spaces, or "worlds," are arranged in relation to one another like three steps on a flight of stairs. In this system, it is precisely Europe—the middle step—that can be called the "earth" in the commonly known sense of that word: it has an old history, is deeply rooted in the past. It can be called the world of traditional human habitation, the world of "earthly life." Russia exists as a gigantic drop "downward" in relation to the surface plan of Europe—a drop of 1,000 and perhaps more kilometers. Thus it is separated from Europe by a vertical wall. We could talk a great deal, and in detail, about the nature of life forms in this "drop." But these life forms are all inherent in mysterious, prehistoric ones. As opposed to the "land of the people," of Europe, colonists descending "downward" to Russia assimilate into it, for a long time but unsuccessfully. In this system, America occupies the third step. It is raised 1,000 kilometers, exactly as far above Europe as Russia descends below it. Life in America, in essence, is life in the cosmos, that is, inside a flying rocket ship. Even though America has a multitude of mountains, earth, and lakes, they are different mountains, a different earth; and this earth is somewhere infinitely high above and distinct from the "standing earth" of Europe. This America is incessantly "rushing" in space along an enormous "unearthly" trajectory, communicating a special supplemental energy and sensation of unheard-of motion to all its inhabitants, precisely like inside a gigantic cabin of a gigantic spaceship. The cosmos, the cosmic ascent—that is what, in contrast to Russia, a person feels during a flight from Europe "upward" to America.

O. Kats, accountant, New York

(English translation by Cynthia Martin)

Ilya Kabakov

Born 1933, Dniepropetrovsk, U.S.S.R. | *Lives and works in New York City*

<u>**Selected Installations**</u> **1999** *The Dialogue* (with Emilia Kabakov), permanent installation, Nordhorn, Germany | *The Life and Creativity of Charles Rosenthal,* Mito Tower, Japan | *The Old Library* (with Emilia Kabakov), The Doelenzaal of the University of Amsterdam, the Netherlands | *The Toilet,* permanent installation, Stedelijk Museum voor Actuele Kunst (S.M.A.K.), Ghent, Belgium | *Examining Pictures, Exhibiting Pictures,* Museum of Contemporary Art, Chicago | **1998** *The Last Step,* permanent installation, Bremerhaven, Germany | *The Children's Hospital* (with Emilia Kabakov), Irish Museum of Modern Art, Dublin | *My Grandfather's Shed,* permanent installation, Mönchehaus Museum für Moderne Kunst, Goslar, Germany | *The Palace of Projects* (with Emilia Kabakov), The Roundhouse, London | *16 Installations,* Museum van Hedenaagse Kunst Antwerpen (MUHKA), Belgium | **1997** *Monument to the Lost Glove,* installation at W. 23rd Street and Broadway, New York | **1996** *Voices behind the Door,* Galerie für Zeitgenössische Kunst, Leipzig | *Healing with Paintings,* permanent installation, Kunsthalle, Hamburg | *On the Roof,* Palais des Beaux-Arts, Brussels | *Retrospective: The Reading Room,* Deichtorhallen, Hamburg | **1995** *School Library,* permanent installation, Stedelijk Museum, Amsterdam | *We Are Living Here,* Centre George Pompidou, Paris | *The Man Who Never Threw Anything Away,* permanent installation, Museet for Samtidskunst, Oslo | **1994** *Operation Room, Mother and Son,* Museum of Contemporary Art, Helsinki | **1993** *School No. 6,* permanent installation, Chinati Foundation, Marfa, Texas | *The Communal Kitchen,* permanent installation, Musée Maillol, Paris | *The Boat of My Life,* Kunstverein, Salzburg, Austria | *The Big Archive,* Stedelijk Museum, Amsterdam | **1992** *The Life of Flies,* Kölnischer Kunstverein, Cologne | **1991** *The Red Wagon,* Kunsthalle Düsseldorf, Germany | **1990** *10 Characters,* Hirshhorn Museum and Sculpture Garden, Smithsonian Institution, Washington, D.C. | **1985** *Along the Margins,* Kunsthalle Bern, Switzerland **<u>Selected Group Exhibitions</u> 1998** *The History of the Interior from Vermeer to Kabakov,* Städelsches Kunstinstitut und Städtische Galerie, Frankfurt-am-Main | **1997** *Looking Up. Reading the Words...,* permanent installation, *Sculpture Projects in Münster,* Germany | *We Were in Kyoto* (with Emilia Kabakov), installation, Venice Biennale, Italy | *Treatment with Memories,* installation, *Whitney Biennial,* Whitney Museum of American Art, New York | **1993** *From Malevich to Kabakov,* Kunsthalle, Cologne | *The Red Pavillion* (with Emilia Kabakov; musical arrangement by Vladimir Tarasov), installation, Venice Biennale, Italy | **1992** *The Toilet,* installation, *Documenta,* Kassel, Germany | **1991** *The Bridge,* installation, *Dislocations,* Museum of Modern Art, New York | **1990** *Rhetorical Image,* New Museum of Contemporary Art, New York | *In the USSR and Beyond,* Stedelijk Museum, Amsterdam | **1988** *Before Supper,* installation, Venice Biennale | **<u>Selected Honors and Awards</u> 1998** Kaiserring Träger, Stadt Goslar, Germany | **1997** Art Critics Association Award, New York | **1995** Chevalier des Arts et des Lettres, Paris | **1993** Honorary Diploma, Venice Biennale | Joseph Beuys Prize, Joseph Beuys Foundation, Basel | Max Beckmann Prize, Frankfurt-am-Main | **1992** Arthur Kopcke Award, Arthur Kopcke Foundation, Copenhagen | **1989** DAAD Fellowship, West Berlin

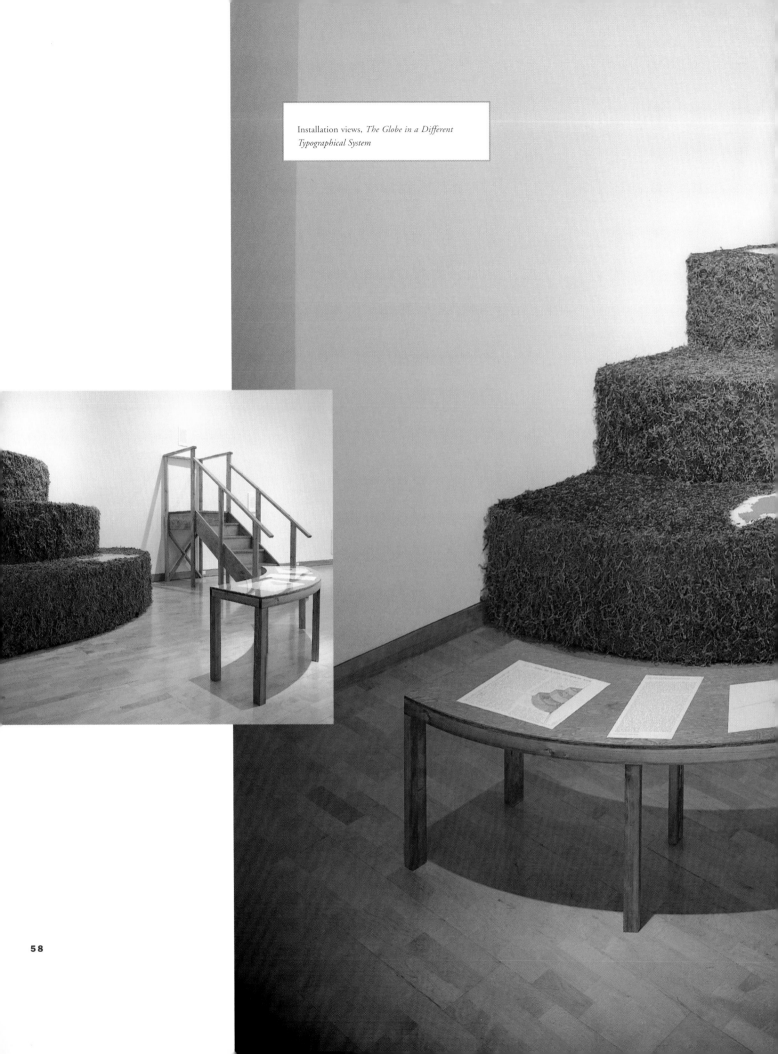

Installation views, *The Globe in a Different Typographical System*

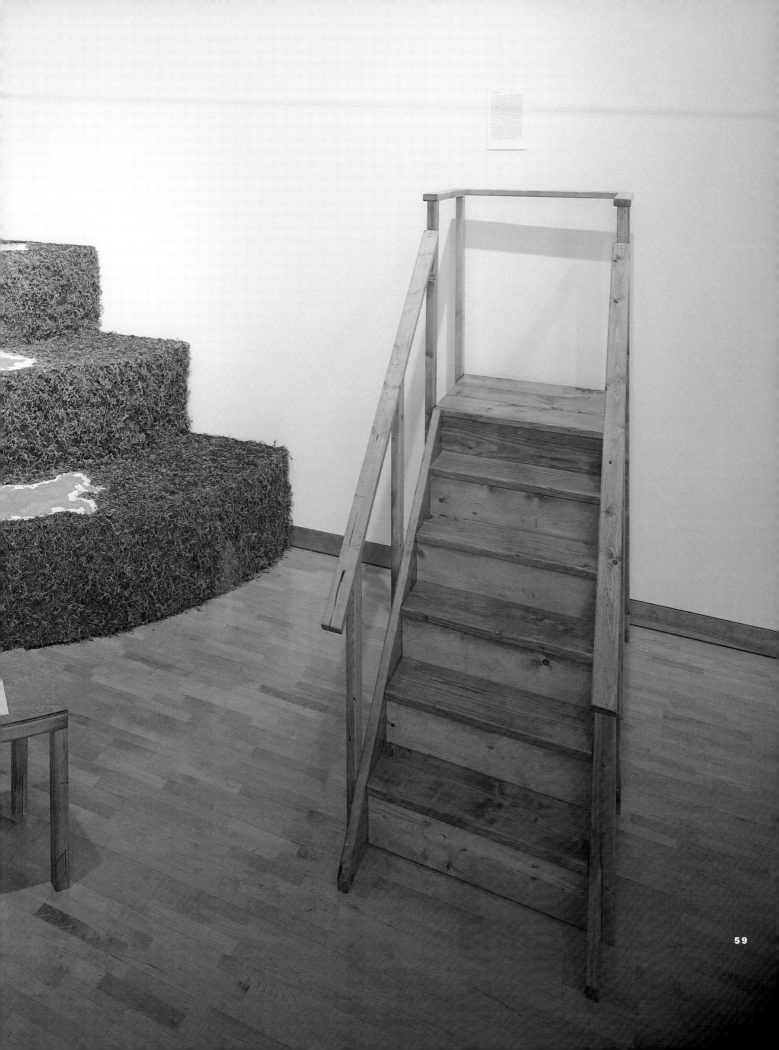

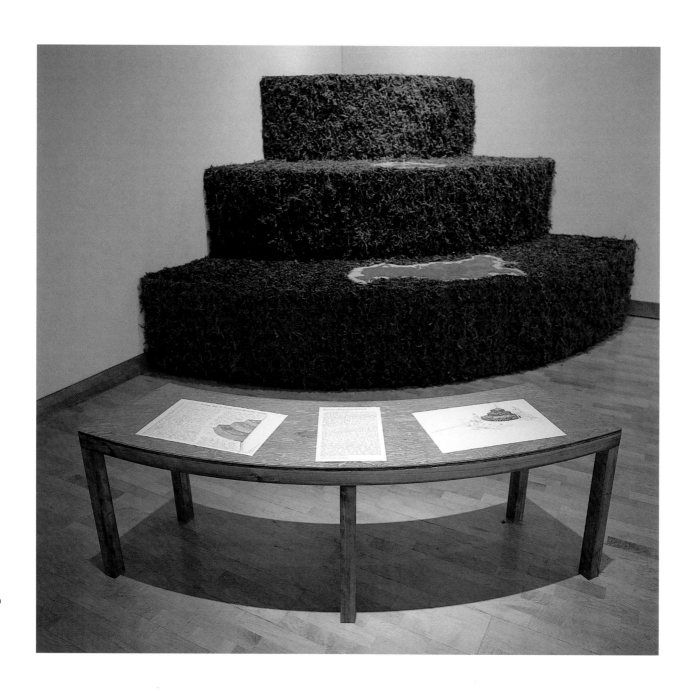

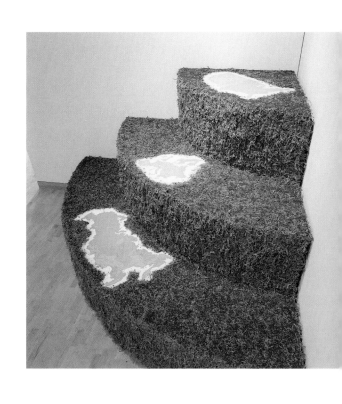

61

KNOWMAD

Motion + Action = Place

The KNOWMAD Confederacy is united by the spirit of MOTION that drives the creative impulse into ACTION and sets the conditions for PLACE.

KNOWMAD (the game) is mapped from a real world of tribal groups, a world that is disappearing due to a complex series of political and cultural changes. The cultural icons of various tribes found in the rugs they weave are recharted here in a virtual world of computer gaming. Women knot bits of wool and creative evidence of human survival. The programmers and designers used these motifs in creating KNOWMAD, keystroking pixels of color into a wire-framed world. Knot on a weft and warp become refreshing pixels on a pitch.

KNOWMAD is a game to play while paying homage both to the tribal world and to the forces of popular culture. Rugs selected by a mapping process refer to the places of tribal rug production as sources of visual and creative energy. Developed into a three-dimensional world and paired with the gaming constraints of time and skill, a new space becomes available in which the player must deal with the excitement of movement, image, and memory.

KNOWMAD seeks to promote a form of travel in which consciousness is imported from the game to the real world. The worlds within the KNOWMAD tents are created in reverence for the beauty of human expression and cultural content found in the tribal rugs.

The nomadic life has had an uneasy history of war and shepherding, of cultural and political strife and struggle. But that history has yielded an eternal gift: the transmission of ideas. Modern nationalistic tendencies in Central Asia, Anatolia, and the Middle East have created territorial boundaries that are bringing the tribal groups' ancient, mapless way of life to an end.

Through this work, the KNOWMAD Confederacy makes a new contribution to the flow of ideas that originated in the commerce of antiquity in the Middle East and that have been transferred to the ever-expanding boundaries of contemporary art. In a cyber-drive fashion, KNOWMAD seeks to catalyze the desire to know more about cultural artifacts and human expression and accelerate beyond preconceived methods of mapping and artistic expression. — *KNOWMAD Confederacy*

KNOWMAD and the KNOWMAD Confederacy

KNOWMAD is a work initiated by Mel Chin and created by a group called the KNOWMAD Confederacy. The group formed after the Weisman Art Museum invited Chin to make an installation work in conjunction with the fall 1999 exhibition *World Views: Maps and Art*. ● The KNOWMAD Confederacy includes artists, computer game designers, and a musician. In addition to Chin, the group's members are: Rocco Basile, Emil Busse, Tom Hambleton, Brett Hawkins, Andrew Lunstad, Chris Parrish-Taylor, Jane Powers, and Osla Thomason-Kuster. Together they created for the Weisman galleries a video arcade driving game that occupies a stylized nomad's tent, replete with Eastern tribal rugs. ● Mel Chin often creates works of art that test the conventional boundaries between art and life by drawing upon situations and media outside the fine arts. KNOWMAD conflates the ancient craft of rug weaving with cutting-edge technology in the form of a contemporary arcade game. Surprising juxta-positions such as this open up a range of interpretive possibilities, both for viewers well acquainted with art museums and for the general public. ● Not long ago, Chin was instrumental in the forming of another task-specific artistic collaborative, the GALA Committee. In 1996 and 1997, the group supplied props, paintings, and other set elements for the popular television series *Melrose Place*. This complex project developed in response to a commission by the Museum of Contemporary Art, Los Angeles to create a public work of art for its 1997 exhibition *Uncommon Sense*.

The images and motifs used in *KNOWMAD* were taken directly from weavings by nomadic peoples of Iran, the Caucasus, Afghanistan, Azerbaijan, Central Asia, and Anatolia (in present-day Turkey). Listed in the following captions are the cultures from which the illustrated images derive.

Upper quadrant, from left to right, top to bottom: Western Anatolia, 19th century; possibly made in the Caucasus, before 1800; possibly made in the Caucasus, early 19th century; Konya area, Anatolia, 18th or early 19th century; East-central Anatolia, 19th century; Shahsavan Confederacy, not dated; Afshars, late 19th century; Kurds, second half of 19th century; Shahsavan Confederacy, second half of 19th century.

Lower quadrant: Shirvan, Caucasus, 19th century; Daghestan (possibly by the Kumyk), 19th century; Chodor, 19th century; Kuba, Azerbaijan, 1860; Shirvan, Caucasus, late 19th century; Salor, first half of 19th century; Shahsavan Confederacy, late 19th century; Timuri, second half of 19th century; Quchan Kurds, late 19th century.

Upper quadrant, from left to right, top to bottom:
Lurs, second half of 19th century; Bakhtiyaris, late 19th century; Khamseh Confederacy, late 19th century; possibly by the Kurds, 18th century; Bakhtiyaris (or Lurs), late 19th century; Khamseh Confederacy, second half of 19th century; Central Anatolia, 15th century; Lurs, late 19th century; Qashqa'i Confederacy, late 19th century.

Lower quadrant: Baluch, late 19th century; Baluch, early 20th century; Baluch, late 19th century; Afshar area, Iran, late 19th century; Afshar area, Iran, late 19th century; Baluch (Mushwani), late 19th century; Qashqa'i Confederacy, late 19th century; Afshar, late 19th century; Afghan Yamut, not dated.

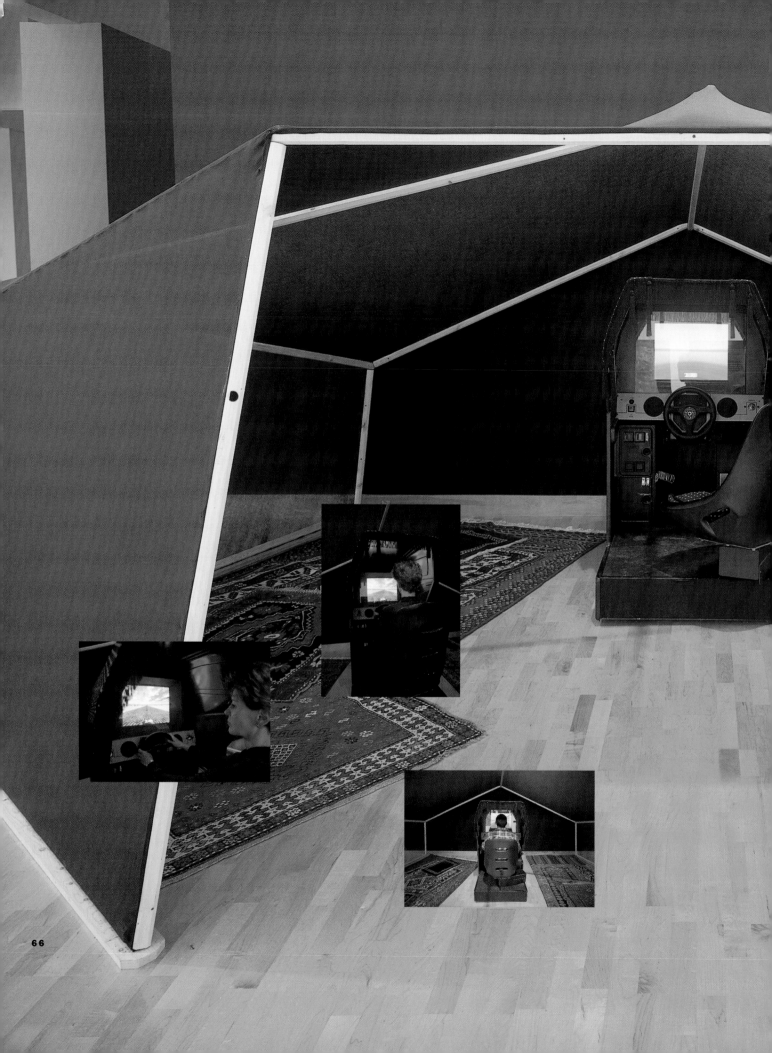

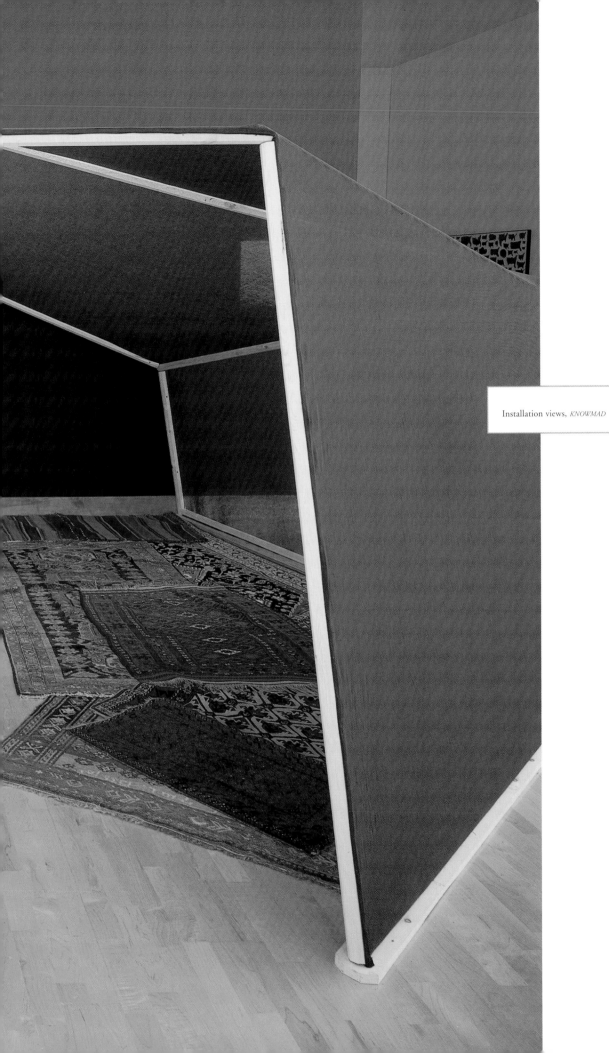

Installation views, *KNOWMAD*

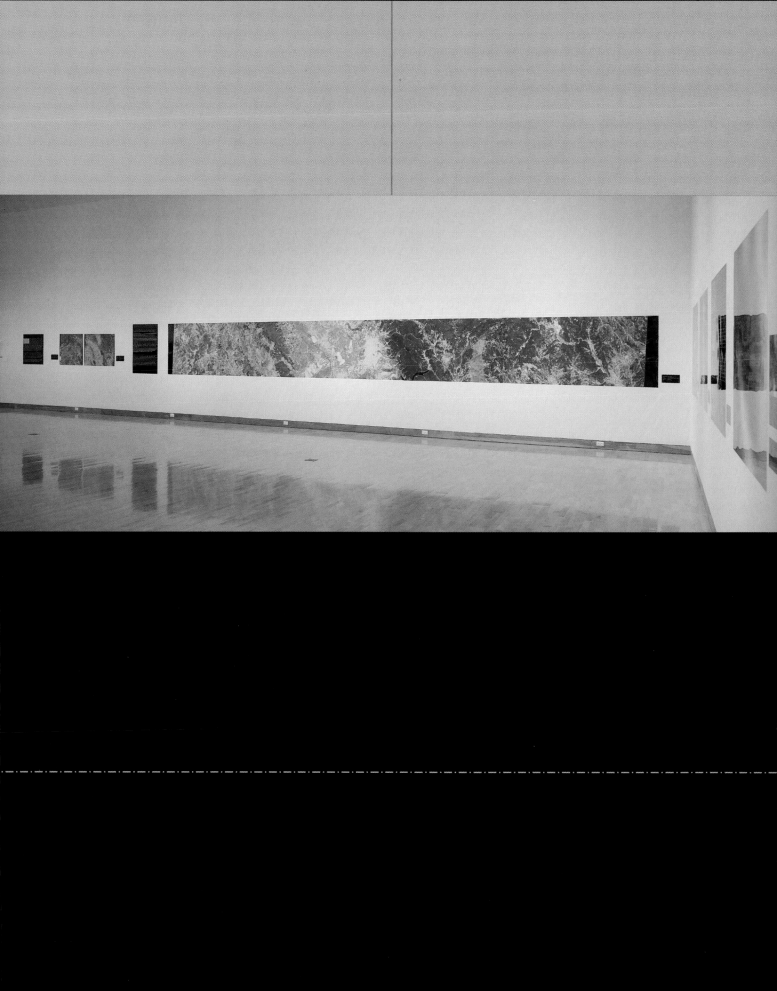

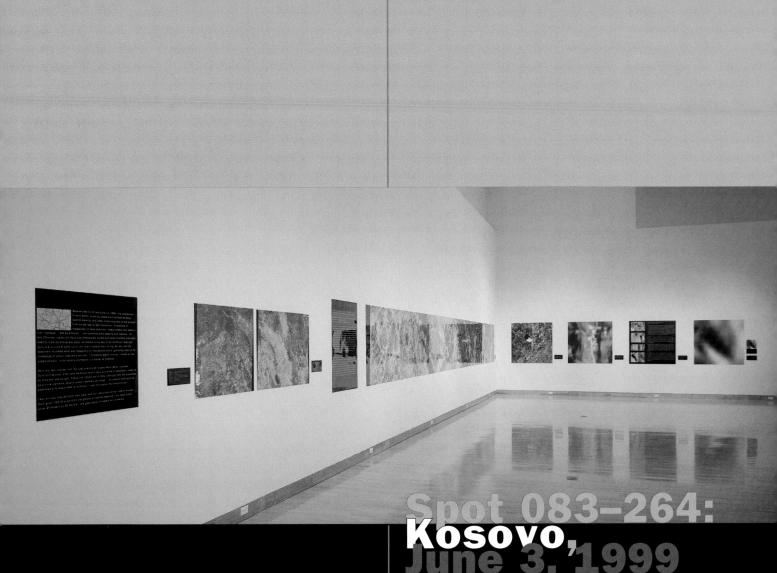

Spot 083–264:
Kosovo, June 3, 1999

Laura Kurgan

Born 1961, Capetown, South Africa | *Lives and works in New York City*

Selected Installations 1995 *You Are Here: Museu,* Museu d'Art Contemporani de Barcelona, Spain | **1994** *You Are Here: Information Drift,* StoreFront for Art and Architecture, New York **Selected Group Exhibitions** 1997 *Close up at a Distance,* installation, *The Art of Detection: Surveillance in Society,* MIT List Visual Arts Center, Cambridge, Massachusetts | **1996** *You Are Here: One Mile Zone,* installation, *The Space of Information,* Banff Center for the Arts, Alberta, Canada | **1995** *Browsing,* installation (with Renée Green), *Architectures of Display,* Portico Home, New York, and World Wide Web site of äda' web. Organized by the Architectural League of New York and Minetta Brook | *Mapping: A Response to MoMA,* American Fine Arts Co., New York | **1993** *Interface: Information Overlay,* installation, *Trade Routes,* New Museum of Contemporary Art, New York | **Selected Honors and Awards** 1996 Artist-in-residence, Banff Center for the Arts, Alberta, Canada | **1995** Young Architects Forum Award, Architectural League of New York | **1988** American Institute of Architects Award, Columbia University, New York

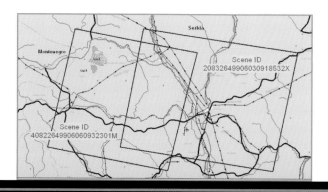

Between March 22 and June 14, 1999, French SPOT commercial satellites aimed their sensors at the sites seen on these pages seventy-two times, collecting data on the ground from an altitude of 822 kilometers. Thousands of megabytes of data were gathered about war, displacement, and destruction, because—not by accident—the satellites were passing over Kosovo. The satellites' ten- and twenty-meter resolution data were immediately stored and made publicly available, on almost every day of the NATO air campaign. Shown here are "data sets" from June 3 and June 6, two of the rare cloudless days during the war, as the satellites recorded what was happening in the "scenes" below, gathering information on the landscape of ethnic cleansing and war. Permanent digital records, created at the speed of light: sixty square kilometers in a matter of seconds.

These are two scenes from the vast quantity of images that SPOT, Landsat, Sovinformsputnik, and other satellites record daily and store in databases, ready to be browsed and bought. They are collections of data—although they are presented as picture elements (pixels) that resemble an image —information waiting to be examined and interpreted, snapshots in time and space.

"The former Yugoslavia is the most listened to, photographed, monitored, overheard and intercepted entity in the history of mankind." — *U.S. State Department official, quoted in the* New York Review of Books.

The Kosovo conflict was, among other things, the one in which classified NATO images were finally released to the public. And these images were not simply pictures of the conduct of the war but also reflected the ostensible reasons why it erupted. Besides footage of bombs and missiles, the public could see ethnic cleansing in progress: high-resolution imagery of mass graves, refugees in the mountains, burning villages, and organized deportations. It was a war in which satellite images were used as a way of forming public opinion. The manner in which they were released, however—as pictures—shows less the facts on the ground than the ability of the technology to record, in minute detail, these facts. No data, strictly speaking, were forthcoming at press briefings, and certainly not the raw data available commercially. As a Pentagon spokesman said, "I won't talk about what kind of imagery that is."

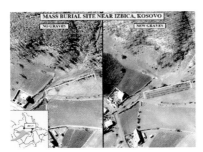

NATO photograph

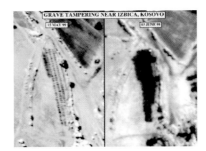

NATO photograph

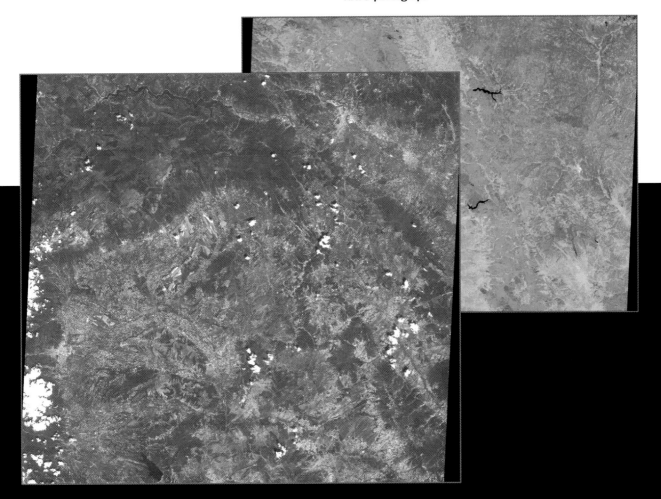

Kosovo	Sat • K-J ID • Date • Time • Camera • Sensor
SPOT Scene	4 • 082-264 • 99.06.06 • 09:32:30 • 1 • M
Cloud Coverage	0-10 percent
Extents	37, 049,284 pixels per band
Top Left	Latitude: N43:01:13 Longitude: E20:21:17
Bottom Right	Latitude: N42:23:34 Longitude: E20:55:22
Coverage	64.81 x 59.92 kilometers
Scale	1 pixel = 10 meters

Kosovo	Sat • K-J ID • Date • Time • Camera • Sensor
SPOT Scene	2• 083-264 • 99.06.03 • 09:18:53 • 2 • X
Cloud Coverage	0 percent
Extents	34, 594 686 pixels: 11,531,562 pixels per band
Top Left	Latitude: N43:01:12 Longitude: E20:39:55
Bottom Right	Latitude: N42:23:40 Longitude: E21:23:02
Coverage	79.88 x 59.780 kilometers
Scale	1 pixel = 20 meters

"On the way to the bus station ... a police officer said to me: 'The war started in Drenica, and we are going to end it here.'" — *Glogovac resident, quoted by Human Rights Watch*

Stretched out horizontally across sixty square meters, the Drenica valley of Kosovo is displayed in what the analysts of overhead imagery call "standard false color." We know how to read this image, more or less, because we know what the colors of the pixels conventionally represent: red is vegetation, purple is marshland or farmland, blue stands for roads, buildings, and bare soil; dark blue is clear water; white represents clouds or smoke; and black is something burned. But add to this what else we know about these picture elements, that they present data. Each pixel designates twenty square meters. Each one has an address, expressed in longitude and latitude, corresponding to a unique territory on the face of the Earth. And each one has a signature, the heat value of that place at the time the satellite passed silently above. That value is expressed as a number, which has in turn an assigned standard false color. The satellite gathers data — we see an image.

Drenica Valley:	
Kosovo	99.06.03
SPOT Scene	2 • 083-264 • 99.06.03 • 09:18:53 • 2 • X
Extents	500 lines: 5,991,000 pixels
Top Left	Latitude: N42:45:56.17 Longitude: E20:41:1.12
Bottom Right	Latitude: N42:33:54.97 Longitude: E21:37:39.91
Coverage	79.88 x 10 kilometers
Scale	1 pixel = 20 meters

What can we see in this image map? It is the record of a war, not just of NATO's air war but of the emptied cities and the burning villages, the refugees and what they've left behind, the mass graves and the crimes that are too easily grouped under the term *ethnic cleansing*. But what can we see? We know that a war is taking place, and that it is presented to us in these colors that tell us something about a landscape. Red: at twenty-meter resolution, the pixels hide the people who are hiding in the hills and forests. Blue: at twenty-meter resolution, the small buildings in the villages are indistinguishable from the roads, and what remains is the large blue trace of the city, Pristina. To its west extends the Drenica valley, where the war started. Has it ended yet?

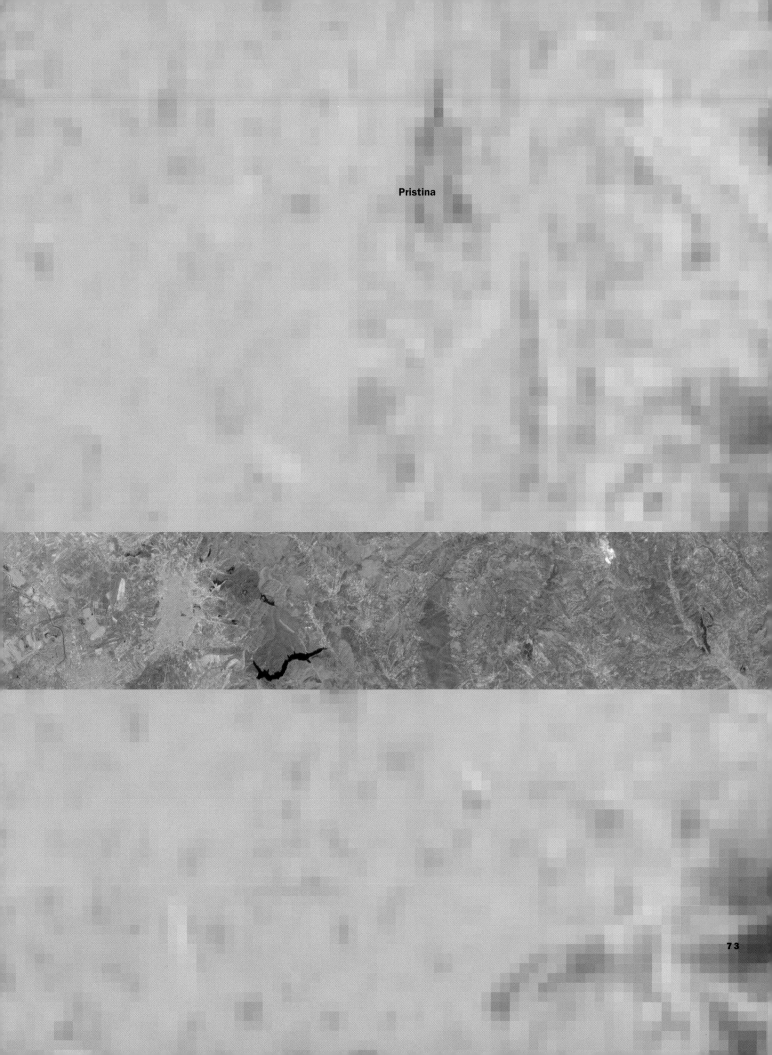

Pristina

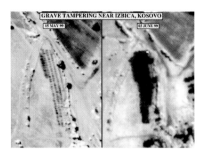

NATO photograph

The record of a double erasure, the evidence of a massacre and of a grave upturned, is digitized and remembered here by high-resolution military satellites. The black is presented to us as the black of freshly upturned soil in the village of Izbica. Absorbing more heat than the adjacent grasslands, it is distinguished and recorded by the satellites' implacable sensors. It would only take the next rain to wipe away the evidence, and then the grass would start growing again. But not on this image.

How can this image be located? In time and space, in history, in memory, or in a database? These—the remainders of the burial ground for scores of villagers in Izbica, killed by their military in March, buried by their neighbors soon after, and then removed from the scene in June—are just a few of the millions of pixels that make up this image. There are certainly many more worth memorializing. But how can we

return this picture to its rightful place in memory, realign it with the data stripped away from it as it became public? For now we are left to our own devices.

It's not very hard to do. Izbica is a small village, locatable on a map with coordinates. In May, as imaged by a German military drone, the grave was just off to the side of a curved road. The road is blurred on the ten-meter SPOT data, but it is recognizable. And, when rotated, the image of the tampered grave released by the Pentagon retrieves one element of the data, a north orientation. Compared with the U.S. Department of Defense image, the coarseness of the pixels on the SPOT data is deceiving—but the shape is the same, and nameable with longitude and latitude points on a map. It can be marked in digital space and time—as a memorial to an event that should not be erased. — *Laura Kurgan*

German Bundeswehr photo

Izbica: Kosovo	99.06.06
SPOT Scene	4 • 082-264 • 99.06.06 • 09:32:30 • 1 • M
Extents	2,500 pixels
Top Left	Latitude: N42:43:47.81 Longitude: E20:38:11.62
Bottom Right	Latitude: N42:42:9.47 Longitude: E20:41:7.87
Coverage	500 x 500 meters
Scale	1 pixel = 10 meters

Grave site	
Izbica: Kosovo	99.06.06
SPOT Scene	4 • 082-264 • 99.06.06 • 09:32:30 • 1 • M
Extents	10,562,500 pixels: enhanced from 100 pixels
Top Left	Latitude: N42:43:45.76 Longitude: E20:39:37.96
Bottom Right	Latitude: N42:43:41.98 Longitude: E20:39:41.48
Coverage	100 x 100 meters
Scale	1 pixel = 3 centimeters

Grave site	
Izbica: Kosovo	99.06.06
SPOT Scene	4 • 082-264 • 99.06.06 • 09:32:30 • 1 • M
Extents	100 pixels
Top Left	Latitude: N42:43:45.76 Longitude: E20:39:37.96
Bottom Right	Latitude: N42:43:41.98 Longitude: E20:39:41.48
Coverage	100 x 100 meters
Scale	1 pixel = 10 meters

WORKS IN THE EXHIBITION

*Dimensions are in inches; height
precedes width precedes depth. Works of
art are listed in alphabetical order.
Maps are listed in chronological order.*

Works of Art

1. Alighiero e Boetti
(Italian, 1940–1994)
Mappa del Mondo, 1978
embroidered cloth,
36-1/2 x 52-1/2
Collection PaineWebber Group, Inc.

2. Joseph Cornell
(American, 1903–1972)
Untitled (Canis Major constellation),
1960
wood, glass, cork,
metal, sand, paper, and paint,
7-5/8 x 12-15/16 x 3-1/2
Walker Art Center, Minneapolis
Gift of the Joseph and Robert Cornell
Memorial Foundation, 1993

3. Kim Dingle
(American, born 1951)
*United Shapes of America III
(Maps of the U.S. Drawn by Las
Vegas Teenagers)*, 1994
oil on wood, 48 x 72
Collection of the artist, courtesy
Sperone Westwater Gallery

4. GALA Committee
Global Syndrome (art prop for the TV
series *Melrose Place*, as part of
the conceptual artwork *In the Name
of the Place*), 1995–97
ink on paper, glass, wine, and cork,
12 x 3-1/2
Collection GALA Committee

5. Nancy Graves
(American, born 1940)
*V Mantes Apenninus Region
of the Moon* (from Lithographs Based
on Geologic Maps of Lunar Orbiter
and *Apollo* Landing Sites), 1972
lithograph on paper, 22-1/2 x 30
Walker Art Center, Minneapolis
Gift of Center for Spring Hill Programs,
1990

6. Robert Indiana
(American, born 1928)
The Confederacy: Mississippi, 1971
screenprint on paper, 39 x 32
Des Moines Art Center
Gift of the American Republic
Insurance Company, 1972

7. Jasper Johns
(American, born 1930)
Two Maps I, 1965–66
color lithograph on paper,
33 x 26-1/2
Frederick R. Weisman Art Museum
Ione and Hudson D. Walker
Acquisitions Fund

8. Joyce Kozloff
(American, born 1942)
*Los Angeles Becoming Mexico City
Becoming Los Angeles*, 1992–93
watercolor, lithograph, and
collage on paper, 22 x 87
Collection Isabel Goldsmith,
Las Alamandas, Mexico

9. Richard Long
(British, born 1945) *A Line of Nights*,
1981
map, photography,
and text on paper, 2 panels,
each 48-13/16 x 34-5/8
Collection Mike and
Penny Winton, Minneapolis

10. Claes Oldenburg
(American, born Sweden, 1929)
Chicago Stuffed with Numbers,
1977
lithograph on paper,
47-3/4 x 31-1/8
Walker Art Center, Minneapolis
Tyler Graphics Archive, 1984

11. Yoko Ono
(American, born Japan, 1933)
Imaginary Map Piece V, 1999
mixed media, variable dimensions
Collection of the artist

12. Miguel Angel Ríos
(Argentine, born 1943)
*Magallanes en la confusión
encontró un océano, #3*
(Magellan in the confusion finds
the ocean), 1994
pleated Cibachrome and paint
on pleated canvas
with pushpins, 117 x 117
Collection of the artist,
courtesy John Weber Gallery

13. Mieko Shiomi
(Japanese, born 1938)
Spatial Poem No. 1, 1965
ink, paint, beaverboard, tape, pins,
glue, and offset text on white
paper (approximately 70 word
locations indicated by flags
pinned to map board),
11-7/8 x 17-3/8 x 1/2 and pins
Gilbert and Lila Silverman Fluxus
Collection, Detroit

14. Jaune Quick-to-See Smith
(Native American, Cree-Flathead-Métis-
Shoshoni, enrolled member of
Confederated Salish and Kootenai
Nation, western Montana,
born 1940)
Indian Country Today, 1996
acrylic and collage on canvas,
60 x 100 (diptych)
Courtesy Steinbaum Krauss Gallery,
New York

15. Robert Watts
(American, born 1923)
Fluxatlas, 1973/1978
plastic box with 24 compartments
containing rocks from locations
around the world and typewritten
paper labels, 8-3/8 x 12-7/8 x 2-1/4
Gilbert and Lila Silverman Fluxus
Collection, Detroit

Commissioned Installations

16. Ilya Kabakov
(born Dnepropetrovsk, U.S.S.R., 1933;
lives in New York City)
*The Globe in a Different Topographical
System*, 1999

17. KNOWMAD Confederacy,
an artists' collaborative formed by
Mel Chin (born Houston, 1951;
lives in Burnsville, North Carolina).
Members include: Rocco Basile
(American, born 1972), Emil Busse
(American, born 1972), Tom
Hambleton (American, born 1962),
Brett Hawkins (American, born 1971),
Andrew Lunstad (American, born
1968), Chris Parrish-Taylor (American,
born 1977), Jane Powers (American,
born 1945), and Osla Thomason-
Kuster (Australian, born 1960)
KNOWMAD, 1999

18. Laura Kurgan
(born Capetown, South Africa, 1961;
lives in New York City)
Spot 083-264, June 3, 1999, Kosovo,
1999

Maps

19. Mimbres Classic Black-on-white
bowl, about 1000–1130/1150
earthenware and pigments,
h. 3-3/8; diam. 8-1/4
Frederick R. Weisman Art Museum
Transfer, Department of
Anthropology, University of Minnesota

20. Mimbres Classic Black-on-white
bowl, about 1000–1130/1150
earthenware and pigments,
h. 3; diam. 7-1/8
Frederick R. Weisman Art Museum
Transfer, Department of
Anthropology, University of Minnesota

21. St. Isidore of Seville
(Spanish, 560?–636)
T-O Map of the World, 1472
woodcut, 11-1/2 x 8-1/4
(single page). In *Etymologiae*
(Augsburg: Gunther Zainer,
1472). James Ford Bell Library,
University of Minnesota

22. Claudius Ptolemy/Klaudios Ptolemaios (Greek, 90–168 A.D.) World Map/Map of England, Ireland, and Scotland, 1482 woodcut, 16-7/8 x 44 (foldout) In *Cosmographia* (Cosmography) (Ulm: Lienhart Holle, 1482). James Ford Bell Library, University of Minnesota

23. Albino de Canepa (Genoese, active 1480–90) Portolan Chart, 1489 hand drawn and hand painted on vellum, 31-5/8 x 47 James Ford Bell Library, University of Minnesota

24. Martin Waldseemüller (German, 1470–1521?) Map of the World on Twelve Gores for a Globe, 1507 woodcut, 9-1/2 x 15-3/16 Published to accompany Waldseemüller's *Cosmographiae Introductio* (Introduction to cosmography) (Saint-Dié, France: Walter and Nikolaus Lud, 1507). James Ford Bell Library, University of Minnesota

25. Johannes Ruysch (Dutch or German, died 1533) *Universalior Cogniti Orbis Tabula ex Recentibus Confecta Observationibus* (A more universal map of the known world, prepared from recent observations), 1508 copperplate engraving, hand colored, 17 x 23 (double-page spread) In Claudius Ptolemy, *Geographia*. 2 vols. (Rome: Bernadinus Venetus de Vitalibus, 1508). James Ford Bell Library, University of Minnesota

26. Abraham Ortelius (Flemish, 1527–1598) *Typus Orbis Terrarum* (Depiction of the world), 1570 copperplate engraving, hand colored, 16-1/2 x 22 (double-page spread) In *Theatrum orbis terrarum* (Theater of the world) (Antwerp: Coppenium Diesth, 1570). James Ford Bell Library, University of Minnesota

27. Georg Braun (German, 1540–1622) and Franz D. Hogenberg (German, died 1590) *Mexico, Regia et Celebris Hispaniae/Cusco, Regni Peru in Novo Orbe* (Mexico/Cuzco, Peru, and the New World), 1572 copperplate engraving, hand colored, 16-1/4 x 20-7/8 (single page) In *Civitates Orbis Terrarum* (Cities of the world) (Cologne, 1572). James Ford Bell Library, University of Minnesota

28. Gerhard Mercator (Flemish, 1512–1594) *Septentrionalium terrarum descriptio* (Description of the northern lands) (Duisburg, 1595) copperplate engraving, 15-7/8 x 20-3/8 (single sheet) James Ford Bell Library, University of Minnesota

29. Johann Bayer (1572–1625) *Orion, the Hunter*, 1603 copperplate engraving, 12-1/4 x 16 (double-page spread) In *Uranometria* (Heavenly composition) (Augsburg: Christophorus Mangnus, 1603). Special Collections and Rare Books, University of Minnesota

30. Joan (Johannes) Blaeu (Dutch, 1596–1673) *Africae nova descriptio* (Africa newly described), 1667 copperplate engraving, hand colored, 18-3/8 x 23-1/4 (single page) In *Le Grand Atlas*. 12 vols. (Amsterdam: Joh. and Cornelium Blaeu, 1667). James Ford Bell Library, University of Minnesota

31. Claude Dablon (French, 1619–1697) *Lac Superieur et autres lieux ou sont les Missions des Peres de la Compagnie de Jesus comprises sous le nom D'Outaouacs* (Lake Superior and other places where there are missions of the fathers of the Company of Jesus included under the name Outaouac), 1672 copperplate engraving, 13-7/8 x 18-3/4 (foldout) In *Relation de ce qui s'est passé de plus remarquable aux missions des peres de la Compagnie de Jesus, en la Nouvelle France, les années 1670 & 1671* (Relation of what is the most remarkable at the missions of the fathers of the Company of Jesus in New France, in the years 1670 and 1671) (Paris: Sebastian Mabre-Cramoisy, 1672). James Ford Bell Library, University of Minnesota

32. Louis Armand de Lom d'Arce, Baron de Lahontan (French, 1666–1715) *A Map of ye Long River and of some others that fall into that small part of ye Great River of Missisipi wich is here laid down*, 1703 copperplate engraving, 9-1/2 x 13-3/4 (foldout) In *New Voyages to North America*. 2 vols. (London: H. Bonwicke, 1703). James Ford Bell Library, University of Minnesota

33. Johann Baptist Homann (German, 1663–1724) *Planiglobii terrestris cum utroq hemisphaerio caelesti generalis exhibitio* (Flat globes of the Earth with each hemisphere of the heavens) (Nuremberg, 1707) copperplate engraving, hand colored, 21-1/8 x 24-5/8 (single sheet) James Ford Bell Library, University of Minnesota

34. Jacques Cassini (Italian, 1677–1756) *Planisphere terrestre: suivant les nouvelles observations des astronomes* (Terrestrial planisphere after the new observations of astronomers), 1713 copperplate engraving, hand colored, 23-3/8 x 28-1/4 (single sheet) (Leiden: Pierre Vander Aa, 1713). James Ford Bell Library, University of Minnesota

35. Sir Robert Montgomery (Scottish, 1680–1731) *A Plan representing the Form of Setling the Districts, or County Divisions in the Margravate of Azilia*, 1717 copperplate engraving, 12-3/4 x 11-3/4 (foldout) In *A discourse concerning the design'd establishment of a new colony to the south of Carolina* (London, 1717). James Ford Bell Library, University of Minnesota

36. Nicolas de Fer (French, 1646–1720) *La Nouvelle France ou la France Occidentale et le cours des grandes rivieres des St. Laurens et de Missisipi* (New France or West France and the course of the great rivers St. Lawrence and Mississippi), 1718 copperplate engraving, hand colored, 41-1/4 x 43-3/4 (single sheet) (Paris: Chez l'Auteur, 1718). James Ford Bell Library, University of Minnesota

37. Stephen Harriman Long (American, 1784–1864) *Stephen Harriman Long Official Expedition Journals for U.S. Corps of Topographical Engineers* vol. 1, 1817; vols. 2 and 3, 1823 ink on paper, vol. 1: 13 x 17-1/4 (double-page spread); vols. 2 and 3: 5-6/7 x 7 (double-page spread) Minnesota Historical Society

38. Joseph E. Heckle
(nationality and life dates unknown)
Topographical Map of Fort
St. Anthony [Fort Snelling], 1823
ink on paper, 26-1/2 x 18-1/2
Minnesota Historical Society, Gift of
W. John and Elizabeth S. Driscoll

39. Meriwether Lewis
(American, 1774–1809)
*Map of Lewis and Clark's Track
across the Western Portion of North
America, from the Mississippi
to the Pacific Ocean; by Order of the
Executive of the United States
in 1804.5.&6*, 1842
copperplate engraving,
6-7/8 x 14 (foldout)
In *History of the Expedition under
the Command of Captains Lewis and
Clarke* [sic], *to the sources of the
Missouri*. 2 vols. (New York: Harper
and Brothers, 1842). James Ford
Bell Library, University of Minnesota

40. *Map of the Organized
Counties of Minnesota*, 1850
engraving, hand colored, 22 x 17-7/8
Thomas, Cowperthwait and
Company, Philadelphia
Minnesota Historical Society

41. *Mississippi River Map*,
July 19, 1866
ink on paper, cloth, wood,
and metal, 128-1/2 x 2-1/2
Loney and Fairchild's Patent Maps
Minnesota Historical Society

42. One Bull
(Hunkpapa Lakota People, active
19th–early 20th centuries)
Custer's War, about 1900
colored pencil and ink on muslin,
39-1/2 x 69-1/4
The Minneapolis Institute of Arts
The Christina N. and Swan J.
Turnblad Memorial Fund

43. *Trunk Highway System,
State of Minnesota*, 1934
screenprint, 9 x 4 (folded);
36 x 31-1/2 (unfolded)
Minnesota Department of Highways
Minnesota Historical Society

44. *Official Map of Minnesota*, 1938
screenprint, 9 x 4 (folded);
36 x 31-1/2 (unfolded)
Minnesota Department of Highways
Minnesota Historical Society

45. *Africa*, 1943
screenprint, 31-1/2 x 29-1/4
Cartographic Section, National
Geographic Society
John R. Borchert Map Library,
University of Minnesota

46. *Shaded Relief Map of the Arabia
Quadrangle of Mars*, 1978
screenprint, 33-3/4 x 26-1/2
U.S. Department of the Interior
Geological Survey, John R. Borchert
Map Library, University of Minnesota

47. *St. Paul West Quadrangle,
Minnesota*, 1967 (revised 1993)
screenprint, 27 x 21-3/4
U.S. Department of the Interior
Geological Survey

48. *Africa*, 1991 (revised 1996)
screenprint, 28-3/4 x 22-1/8
Cartographic Division, National
Geographic Society

49. *The Topography of Mars
Revealed by Mars Orbiter Laser
Altimeter Measurements
Taken through April 15, 1999*, 1999
laser print on paper, 22-1/8 x 21-1/2
Mars Orbiter Laser Altimeter
Science Team

50. *Paul Bunyan's Playground in
Northern Minnesota*, undated
screenprint, 21 x 15-1/4
Printed by Paul Bunyan Playground
Association, Curtis Hotel, Minneapolis
Minnesota Historical Society

Maps in Literature

51. *The Island of Utopia*, 1518
woodcut, 13-5/8 x 8-1/2
(single page)
In St. Sir Thomas More, *Utopia*
(1518; reprint New York: Scott-Thaw
Company, 1903).
Special Collections and
Rare Books, University of Minnesota

52. Map of Brobdingnag, New Albion,
and North America, 1726
In Jonathan Swift, *Travels into Several
Remote Nations of the World.
In Four Parts. By Lemuel Gulliver,
first a surgeon, and then a
captain of several ships*, vol. 1
(London: Benj. Motte, 1726).
7-3/8 x 4-1/2 (single page)
Special Collections and Rare Books,
University of Minnesota

53. *Jefferson, Yoknapatawpha Co.,
Mississippi*, 1936
In William Faulkner, *Absalom,
Absalom!* (New York: Random
House, 1936).
10-3/4 x 8 (foldout)
Special Collections and Rare Books,
University of Minnesota

54. J. R. R. Tolkien
(English, 1892–1973)
Wilderland, endpaper 2, 1937
In *The Hobbit, or There and Back Again*
(London: Allen and Unwin, 1937).
7-1/2 x 10-1/2 (double-page spread)
Kerlan Collection of Children's
Literature, University of Minnesota

55. E. H. Shepard
(English, 1879–1976)
The World of Pooh, 1926
In A. A. Milne, *The World of Pooh,
The Complete Winnie-the-Pooh
and The House at Pooh Corner*
(New York: E. P. Dutton, 1957).
8-15/16 x 12-1/2
(double-page spread)
Kerlan Collection of Children's
Literature, University of Minnesota

56. *Treasure Island*, 1883
In Robert Louis Stevenson, *Treasure
Island* (1883; reprint London:
Nonesuch Press, 1963).
9 x 5-1/2 (single page)
Kerlan Collection of Children's
Literature, University of Minnesota

Selected Bibliography

Alfrey, Nicolas, and Stephen Daniels, eds. *Mapping the Landscape.* Exh. cat. Nottingham, England: University Art Gallery, Castle Museum, 1990.

Bianchi, Paolo and Sabine Folie. *Atlas Mapping: Künstler als Kartographen Kartographie als Kultur.* Exh. cat. Linz: Offenes Kulturhaus, 1997.

Brayer, Marie-Ange, "Mesures d'une fiction picturale: La carte de geographie," *exposé* 2 (1995): 6–23.

Braun, George. *Cities of the World.* London: Magna Books, 1990.

Brown, Lloyd, *The Story of Maps.* Boston: Little, Brown, 1949.

Calabrese, Omar, et al. *Hic sunt leones: geografica e viaggi straordinari.* Exh. cat. Rome: Centro Palatino, 1983.

Carter, Paul. *The Road to Botany Bay: An Exploration of Landscape and History.* New York: Alfred A. Knopf, 1988.

Cartes et figures de la terre. Exh cat. Paris: Centre Georges Pompidou, 1980.

Conley, Tom. *The Self-Made Map: Cartographic Writing in Early Modern France.* Minneapolis: University of Minnesota Press, 1996.

Cordell, D. K. Yee, "Cartography in China." In *The History of Cartography.* Vol. 2, bk. 3. Edited by David Woodward and G. Malcolm Lewis. Chicago: University of Chicago Press, 1998.

Cosgrove, Denis, ed. *Mappings.* London: Reaktion Books, 1999.

Edlefsen, David, *A World of Maps.* Exh. cat. Anchorage, Ala.: Anchorage Museum of History and Art, 1994.

Edney, Matthew H. *Mapping an Empire: The Geographical Construction of British India 1765–1843.* Chicago: University of Chicago Press, 1997.

Fend, Peter. *Mapping: A Response to MoMA.* Exh. cat. New York: American Fine Arts, 1995.

Fitzgerald, C. P. *The Chinese View of Their Place in the World.* London: Oxford University Press, 1964.

Foucault, Michel. "Questions on Geography." In *Power/Knowledge: Selected Interviews and Other Writings, 1972–1977.* Edited by Colin Gordon. Translated by Colin Gordon, Leo Marshall, John Mepham, and Kate Soper. New York: Pantheon, 1980.

Frank, Peter. *Mapped Art: Charts, Routes, Regions.* Exh. cat. New York: Independent Curators Incorporated, 1981.

Hall, Stephen S. *Mapping the Next Millennium: The Discovery of New Geographies.* New York: Random House, 1992.

Haraway, Donna. "Deanimations: Maps and Portraits of Life Itself." In *Picturing Science, Producing Art.* Edited by Caroline A. Jones and Peter Galison. New York: Routledge, 1998.

Harley, J. B. "Maps, Knowledge, and Power." In *The Iconography of Landscape: Essays on the Symbolic Representation, Design, and Use of Past Environments.* Edited by Denis E. Cosgrove and Stephen Daniels. Cambridge, England: Cambridge University Press, 1988.

———, and David Woodward, eds. *The History of Cartography.* 2 vols. to date. Chicago: University of Chicago Press, 1987–.

Harvey, P. D. A. *Mappa Mundi: The Hereford World Map.* Toronto: University of Toronto Press, 1996.

Hudson, Alice. C. *Mapping the New World.* Exh. brochure. New York: New York Public Library, 1992.

Kaplan, Robert D. "The Coming Anarchy," *Atlantic Monthly* 273, no. 2 (February 1994): 44–76.

Koscevic, Zelimir. *Cartographers.* Exh. cat. Zagreb, Croatia: Museum of Contemporary Art, 1997.

Lestringant, Frank. *Mapping the Renaissance World: The Geographical Imagination in the Age of Discovery.* Translated by David Fausett. Berkeley: University of California Press, 1994.

Lewis, G. Malcolm, ed. *Cartographic Encounters: Perspectives on Native American Mapmaking and Map Use.* Chicago: University of Chicago Press, 1998.

McClintock, Anne. "Maidens, Maps, and Mines: The Reinvention of Patriarchy in Colonial South Africa," *South Atlantic Quarterly* 87, no. 1 (winter 1988): 147–92.

McCullagh, Susan Folds. "Art and Cartography: Two Exhibitions," *Mapline,* special no. 5 (October 1980): 1–20.

Monmonier, Mark. *Drawing the Line: Tales of Maps and Cartocontroversy.* New York: Henry Holt, 1995.

———. *How to Lie with Maps.* Chicago: University of Chicago Press, 1991; 2d ed., 1996.

Oliveira, Nicolas de, et al. *Installation Art.* Washington, D.C.: Smithsonian Institution Press, 1994.

Post, J. B. *An Atlas of Fantasy.* Baltimore: Mirage Press, 1973; rev. ed., New York: Ballantine Books, 1979.

Prince, Hugh. "Art and Agrarian Change, 1710–1815." In *The Iconography of Landscape: Essays on the Symbolic Representation, Design, and Use of Past Environments.* Edited by Denis E. Cosgrove and Stephen Daniels. Cambridge, England: Cambridge University Press, 1988.

Rabasa, Jose. "Allegories of the Atlas." In *Europe and Its Others.* Vol. 2. Edited by Francis Barker. Colchester, England: University of Essex, 1985.

Rees, Ronald. "Historical Links between Cartography and Art," *Geographical Review* 70, no. 1 (1980): 60–78.

Reeves, Eileen. "Reading Maps," *Word and Image* 9, no. 1 (1993): 51–65.

Robertson, Jean, and Craig McDaniel. *Exploring Maps.* Exh. cat. Terre Haute, Ind.: Turman Art Gallery, Indiana State University, 1992.

Robinson, Arthur H., and Barbara Bartz Petchenik. *The Nature of Maps: Essays Toward Understanding Maps and Mapping.* Chicago: University of Chicago Press, 1976.

Schwartz, Seymour I., and Ralph E. Ehrenberg. *The Mapping of America.* New York: Harry N. Abrams, 1980.

Shapiro, Michael J. *Violent Cartographies: Mapping Cultures of War.* Minneapolis: University of Minnesota Press, 1997.

Shirley, Rodney W. *The Mapping of the World: Early Printed World Maps, 1472–1700.* London: Holland Press, 1983.

Shohat, Ella. "Imaging Terra Incognita: The Disciplinary Gaze of Empire," *Public Culture* 3, no. 2 (spring 1991): 41–70.

Smith, Roberta. *4 Artists and the Map: Image/Process/Data/Place.* Exh. cat. Lawrence, Kans.: Spencer Museum of Art, University of Kansas, 1981.

Snyder, John P. *Flattening the Earth: Two Thousand Years of Map Projections.* Chicago: University of Chicago Press, 1993.

Sparke, Matthew. "A Map That Roared and an Original Atlas: Canada, Cartography, and the Narration of a Nation," *Annals of the Association of American Geographers* 88, no. 3 (1998): 463–95.

Storr, Robert. *Mapping.* Exh. cat. New York: Museum of Modern Art, 1994.

Tuan, Yi-Fu. *Topophilia: A Study of Environmental Perception, Attitudes, and Values.* Englewood Cliffs, N.J.: Prentice Hall, 1974.

———. *Space and Place: The Perspective of Experience.* Minneapolis: University of Minnesota Press, 1977.

———. *The Good Life.* Madison, Wisc.: University of Wisconsin Press, 1986.

Turnbull, David, with Helen Watson. *Maps Are Territories: Science Is an Atlas.* Geelong, Victoria, Australia: Deakins University, 1989; Chicago: University of Chicago Press, 1993.

Warhus, Mark. *Another America: Native American Maps and the History of Our Land.* New York: St. Martin's Press, 1997.

Whitfield, Peter. *The Image of the World: Twenty Centuries of World Maps.* San Francisco: Pomegranate Artbooks in association with the British Library, 1994.

———. *The Mapping of the Heavens.* San Francisco: Pomegranate Artbooks, 1995.

———. *The Charting of the Oceans: Ten Centuries of Maritime Maps.* San Francisco: Pomegranate Artbooks, 1996.

———. *New Found Lands: Maps in the History of Exploration.* New York: Routledge, 1998.

Wilford, John Noble. *The Mapmakers.* New York: Alfred A. Knopf, 1981.

Wombell, Paul, ed. *The Globe: Representing the World.* York, England: Impressions Gallery of Photography, 1989.

Wood, Denis, with Jon Fels. *The Power of Maps.* New York: Guilford Press, 1992.

Woodward, David. "Reality, Symbolism, Time, and Space in Medieval World Maps," *Annals of the Association of American Geographers* 75, no. 5 (1985): 510–21.

———, ed. *Art and Cartography: Six Historical Essays.* Chicago: University of Chicago Press, 1987.

———. "The Representation of the World." In *Geography's Inner Worlds: Pervasive Themes in Contemporary American Geography.* Edited by Ronald L. Abler, Melvin G. Marcus, and Judy M. Olson. New Brunswick, N.J.: Rutgers University Press, 1992.

Zelinsky, Wilbur. "The First and Last Frontier of Communication: The Map as Mystery," *Bulletin, Special Libraries Association, Geography and Map Division,* no. 94 (1973): 2–8.